CraftScapes

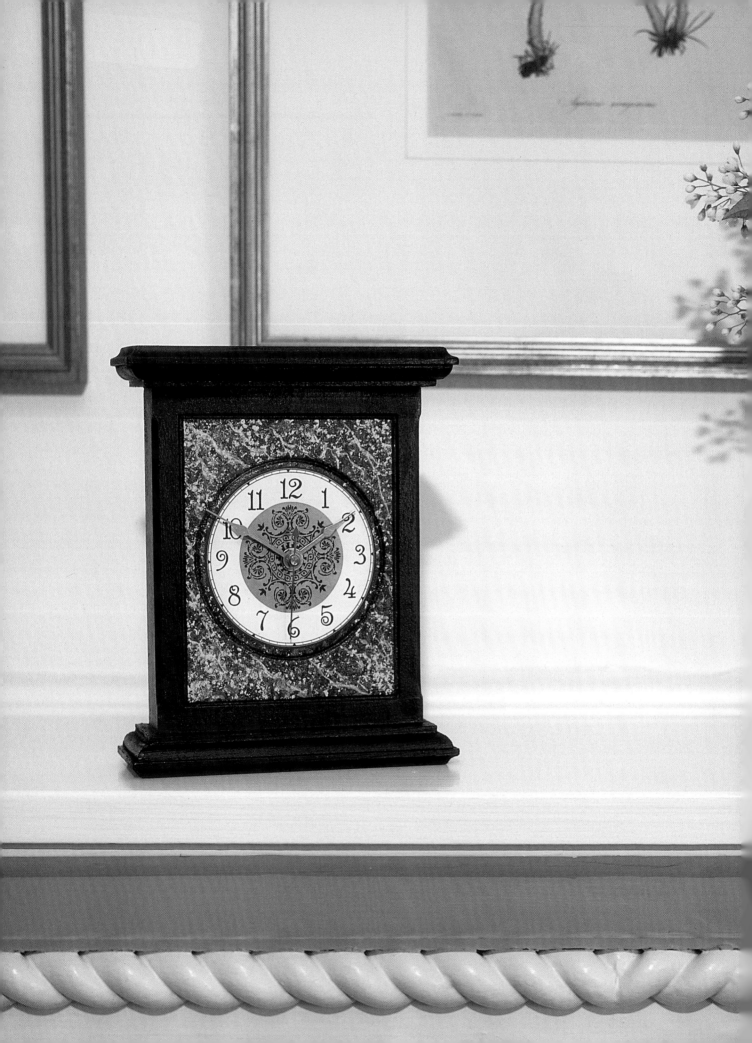

CraftScapes

by Sue Warden

Gifts for Family and Friends

50 Quick and Easy Projects to Make at Home

RAINCOAST BOOKS

Vancouver

A Denise Schon Book

A Denise Schon Book

Copyright © 1998 Denise Schon Books Inc.

Text copyright © 1998 Life Network Inc.

Watch "Sue Warden CraftScapes" daily on Life Network. Consult your local listings for times or download your own personal schedule at www.lifenetwork.ca.

Life Network, a subsidiary of Atlantis Broadcasting
1155 Leslie Street
Toronto, Ontario
M3C 2J6
Telephone: (416) 444-9494
Fax: (416) 444-0018

The information in this book is accurate to the best of the author's knowledge. Nevertheless, the reader remains responsible for the selection of tools and materials. When working with tools, paints and other chemical compounds be sure to observe the manufacturer's instructions and use care, good judgment and common sense.

First published in 1998 by
Raincoast Books
8680 Cambie Street
Vancouver, B.C.
V6P 6M9
(604) 323-7100
Web site: www.raincoast.com

Canadian Cataloguing in Publication Data
 Warden, Sue
 CraftScapes

 ISBN 1-55192-186-3
 1. Handicraft 2. Gifts. I. Title.
 TT157.W37 1998 745.5 C98-910512-1

Design: Counterpunch/Linda Gustafson
Editor: Jennifer Glossop
Copy Editor: Siobhan McMenemy
Photography: Andrew Leyerle

Printed and bound in Canada
9 8 7 6 5 4 3 2 1

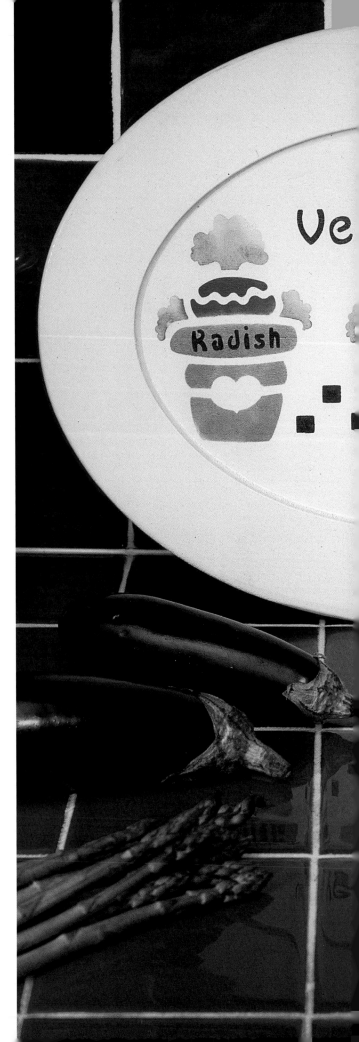

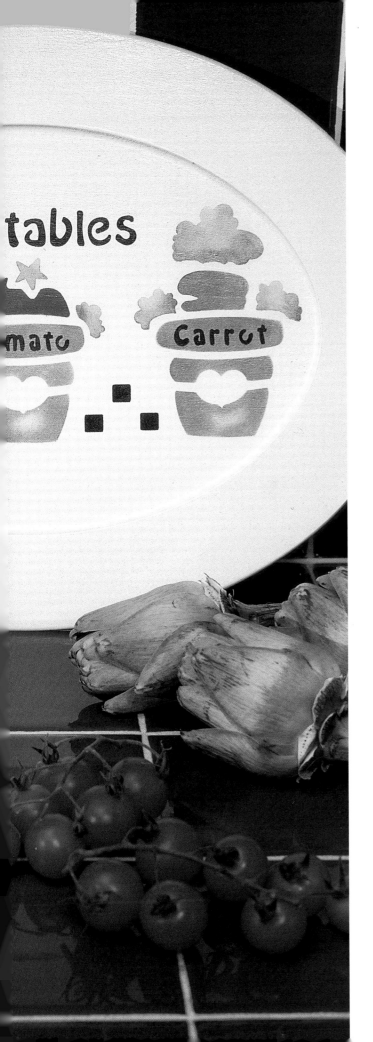

To my mom and dad, who have stood behind me
through every chapter of my life. Love ya!

Contents

Acknowledgements ix

Introduction x

Commonly-used Crafting Tools xiii

Fabulous Florals

Eucalyptus Door Ornament 3

"Crackpot" Fall Wreath 5

Floral Hogarth Curve 7

Nature's Delight Raffia Wreath 9

Sunflower Topiary 11

Silk Swag 13

Southwest Moss Wreath 15

Floral Grapevine Grouping 17

Easy Rose Basket 19

Greenery Topiary 21

Pedestal Floral Arrangement 23

Botanical Box Frame 25

The Painted Pro

Antiqued Candlesticks 29

Magic Magazine Boxes 31

Star Planter 33

Handy Homemade Blackboard 35

Funky Footstool 37

Faux Embossed Tray 39

Leather-Look Wall Sconce 41

Block Stained Chargers 43

Traditionally Beautiful Shelf 45

Tissue Box Planter 47

Easy Marbled Clock 49

Fiesta Bandanna Napkin Rings 51

Stencil Magic

Whimsical Wisteria Pillows 55

Easy Art Deco 57

Hand-Painted Apple Mugs 59

Veggie-Stenciled Tray 61

Bath-Time Decor for Kids 63

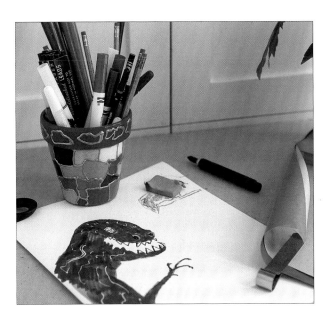

It's Christmas

Christmas Napkin Caddy 67

Copper Nut Jar 69

Shimmering Christmas Wreath 71

Christmas Ball Drop 73

Winter Frost Decorator Bottles 75

Kid's Day

Kid's Crayon Caddy 79

Bugs 'n' Critters Blackboard 81

Pom Pom Topiary Tree 83

Tropical Rainstick 85

Friendship Game 87

Clay Pot Piggy Bank 89

Spruced-Up Lunch Bags 91

Colorful Button Picture Frame 93

Kid's Creative Apron 95

Perfect Pencils 97

Funky Mouse Pads 99

Decoupage Decadence

Keepsake Box 103

Cozy Coat Rack 105

Just for Him 107

Noah's Ark Kid's Accessories 109

Angelic Gift Box 111

Suppliers 112

Acknowledgements

As I began to write these acknowledgments, I was overwhelmed with gratitude for all the people who helped make this book happen.

I'd like to send a special thanks to all my associates and friends at Life Network whose commitment to both the television show *Sue Warden CraftScapes* and this book has enabled me to share my ideas with the crafting community. Heartfelt thanks to Angela Jennings, Kim McIlwaine, Andrea Russell, Mike Nolan, Gord Ross and the wonderful creative and technical crew of the show for their hours of hard work and devotion. I'm so lucky to have had the opportunity to work with such a great group of people.

I am also very grateful to Michaels, The Arts and Crafts Store, which has graciously supported my television program. And thanks to the many arts and crafts manufacturers who have willingly given their expertise and product support.

A special thank you goes to Denise Schon Books Inc. and Raincoast Books for guiding me through the wonderful world of book publishing.

I particularly want to express my gratitude and appreciation to my family and friends who have always stood by me and given me the best advice I could ever hope for.

I'd especially like to thank my husband, Martin, and son, Nicholas, who graciously endured the late nights I spent at the computer, the piles of laundry and the "heat and eat" meals but still gave me unconditional love and support. This truly is what life is all about.

The dream of this book started with the encouragement and enthusiasm of the viewers of my show. To them and to you, the readers of this book, thank you.

Introduction

Crafting is an important part of my personal and professional life. I know from my TV show, *Sue Warden CraftScapes,* that I am not alone. Creating a decorative swag or a practical magazine box, making something with your own hands to give as a gift or to sell at a charity craft show brings a special sense of satisfaction.

This book features 50 favorite quick and easy projects from the most popular episodes of my TV show. It is designed to appeal to everyone – from novice crafters and kids to seasoned veterans.

I have separated the book into chapters: floral design, painting, stenciling, Christmas ideas, kid's projects and decoupage. Each chapter provides instructions for various projects, all of which can be completed at home in a short period of time. You can choose to do one individual craft for yourself or to give as a gift, or to coordinate several to enhance a room.

The first chapter will help you create beautiful floral arrangements. I have included my favorites, like the Southwest Moss Wreath and the Pedestal Floral Arrangement. Although I have heard it said that floral designing is somewhat intimidating, I can tell you from experience that it is as easy and satisfying as any other craft project. Once you start to work with silk and dried flowers, you will enjoy the relaxing effects and be pleasantly surprised with the results. My advice to novice floral designers is to start small, using silk flowers, as they are very forgiving. If you are a pro, you may want to change the instructions slightly to create a whole different look and challenge yourself a little further. Remember to use colors that suit your own decor and to have fun!

Choosing twelve painted projects from all the extraordinary ideas on the show was probably the most difficult choice I had to make. I think, however, I've managed to find an amazing mix, ranging from the most elegant wall sconces to fun and funky planters. As I have often mentioned on the show, painting is not difficult, and with all the awesome products we have available to us, you do not have to be a professional to achieve really fabulous results. The best tips I can give you are to take your time and allow each coat of paint

to dry completely before moving on to the next. Refer to the photographs of the finished projects if you are ever in doubt.

What about those color combinations? Of course, not every combination in this book is going to suit your taste. It is up to you to decide where to make color substitutions. Is your kitchen soft pastel colors? Perhaps a bright green and yellow planter will not enhance your decor. Simply find colors that you enjoy and incorporate them into the project. It is that easy!

With every year that goes by, more and more charming stencils flood the market. As I travel throughout North America, the new and innovative stencils and stenciling ideas available never cease to amaze me. Stencils are no longer just for home decor; they can now be used for memory book projects, decorating placemats and tablecloths, linens and sachets. Stenciling creates a beautifully perfect image and allows those who are not necessarily comfortable painting free hand the capability to create special designs. Regardless of whether you choose to use water- or oil-based paints, this art form will give you professional results every time.

I certainly couldn't leave out some of the special holiday ideas we have had fun cultivating. The Shimmering Christmas Wreath is such a special addition to the season and the Winter Frost Decorator Bottles are a great gift-giving idea. The holiday season creeps up on us so quickly and before we know it, Christmas is here and we have not completed all the hand made gifts we had intended to make. The answer – start early! Head straight for the Christmas idea section of the book and go for it, no matter what time of year it is. You may even want to change some of the other projects in the book to reflect the festive season. Make a Christmas planter or centerpiece simply by changing some of the materials and colors.

When we decided to do "Kid's Day" on the show, we had no idea we would receive such a positive response. Letters from children across the country came pouring in and we loved it! So here are several of those great projects that the kids keep coming back for. They

are easy to accomplish and fun to make for all age groups. From the Tropical Rainstick to the Pom Pom Topiary Tree, there is something for everyone in the kid's chapter of the book. Oh, and by the way, kids, you may want to let your parents get in on the action. Keep sending me those great letters and pictures of your projects. I love hearing from you!

Finally, although decoupage has been around for a very long time and most of us are familiar with it, I felt this wonderful art form deserved a separate section in the book. I hope you take pleasure from the projects I have chosen.

Every attempt has been made to use easy-to-find products. However, feel free to substitute at any time. After all, crafting is very individual and adding your own special touch is what makes your work unique.

I've also included a photograph on the following page of some of the commonly-used crafting tools you'll need to get started.

I sincerely hope you enjoy this book – a book written with you in mind and designed to give you hours of crafting pleasure. Use it as a workbook. The tattered corners will tell me you are having fun!

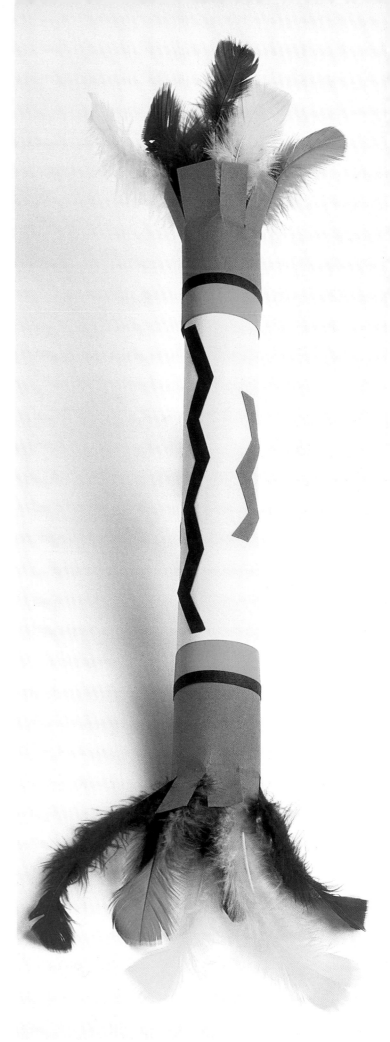

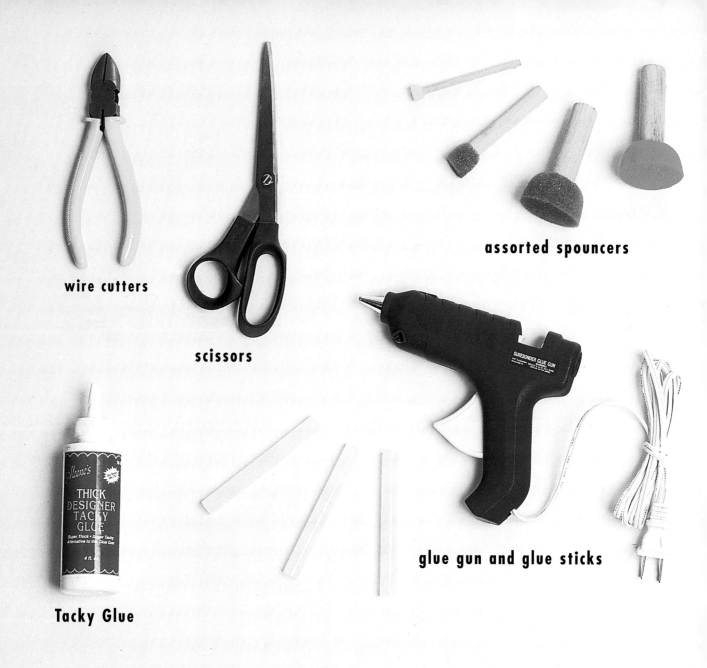

wire cutters

scissors

assorted spouncers

glue gun and glue sticks

Tacky Glue

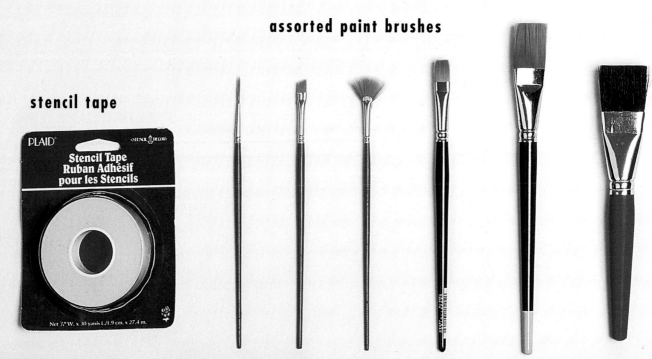

assorted paint brushes

stencil tape

Commonly-used Crafting Tools

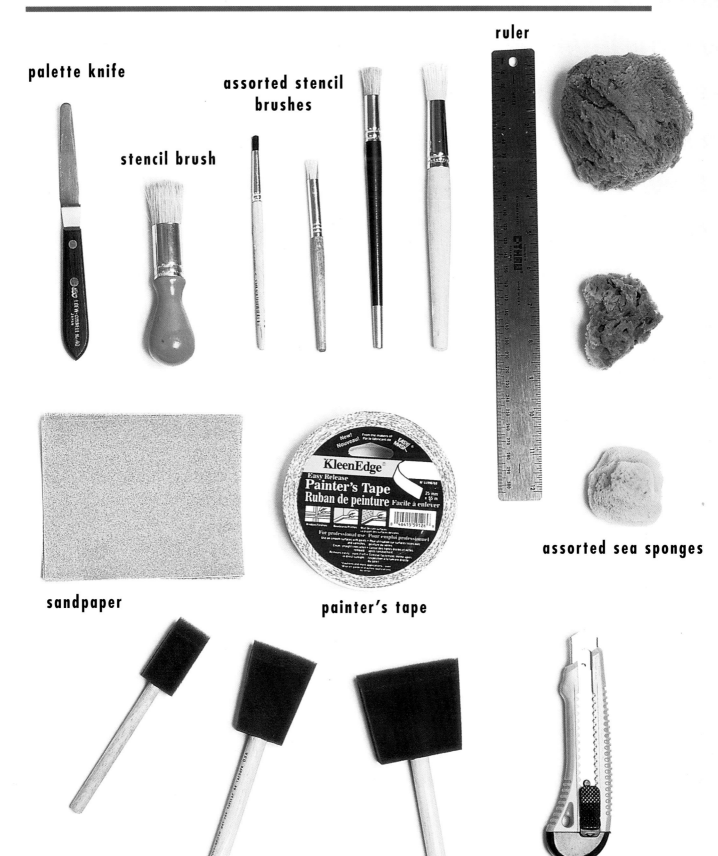

palette knife

stencil brush

assorted stencil brushes

ruler

sandpaper

painter's tape

assorted sea sponges

assorted foam brushes

X-acto knife

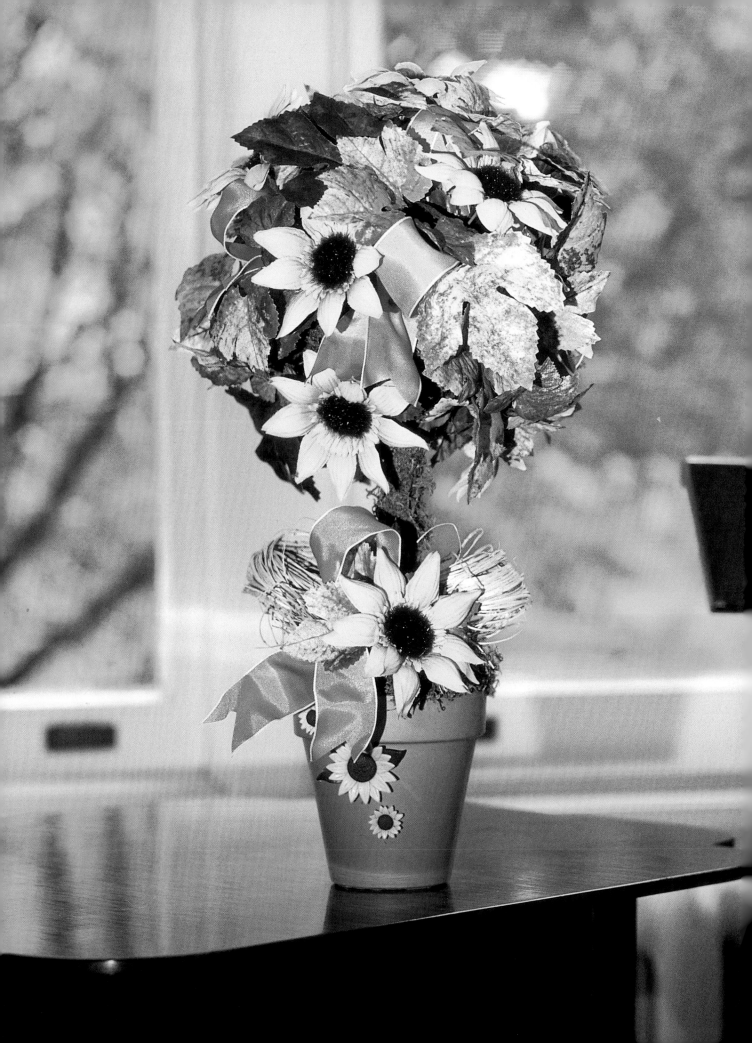

Fabulous Florals

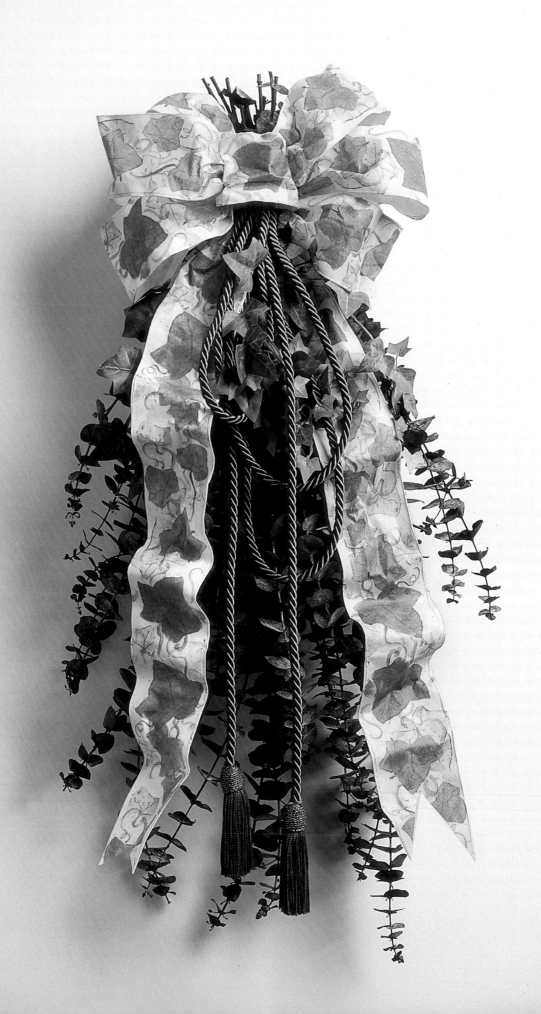

Eucalyptus Door Ornament

Materials

1 large package green eucalyptus boughs
1 paddle 24- to 26-gauge floral wire
1 package Plaid Shaper Paper Ivy
1 small silk ivy bush
4 yards (3.65 m) Domcord Belding moss
 green cording
2 Domcord Belding moss green tassels

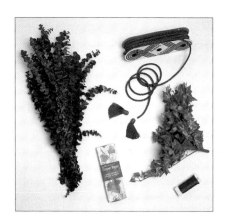

Tools

scissors
wire cutters
glue gun with glue sticks

Instructions

1. Sort the eucalyptus boughs into long, medium and short pieces. Remove any small offspring pieces from the long stems. Set the short stems aside for future projects.

2. Gather the ends of the long pieces and spread the boughs to form a fan shape. Spread the medium pieces on top. When you have a nice, full fan, wrap a length of wire around the stems about 4 inches (10 cm) from the ends of the boughs.

3. Make a multi-loop bow with the Shaper Paper, leaving long tails. Cut a "V" at the end of each tail. Wire the bow to the wired stems of the eucalyptus.

4. With wire cutters, cut the silk ivy bush apart. Insert and glue various lengths of silk ivy draping down from the bow.

5. Wire large loops of the cording together. Glue this bow slightly under the middle of the ribbon bow.

6. Attach the tassels to the ends of the cording.

Sue's Tip

This wonderful floral project is both inexpensive and easy to make. To vary the design with the seasons, choose different types and colors of ribbon and cording. For a Christmas door ornament, use holiday ribbon and flowers, and substitute red or burgundy cording for the green.

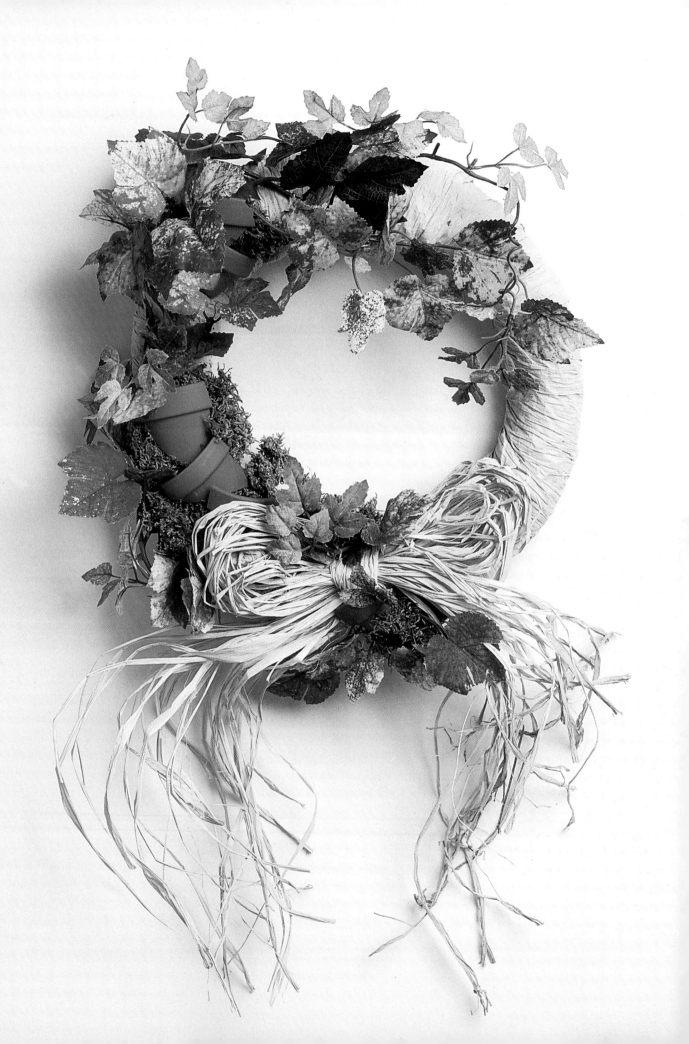

"Crackpot" Fall Wreath

Materials

4 yards (3.65 m) natural papertwist ribbon
1 12-inch (30 cm) straw wreath
1 small package floral "U" pins
1 small bag natural raffia
1 fall-leaf garland
1 bag green moss
2 2-inch (5 cm) clay pots

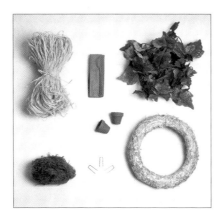

Tools

glue gun with glue sticks
scissors
plastic bag
hammer
wire cutters

Instructions

1. Untwist the ribbon. Secure one end of the ribbon to the wreath with floral "U" pins. Wrap the ribbon around the wreath. Continue wrapping, overlapping the edges, until the entire surface is covered. Secure the other end of the ribbon down.

2. With raffia, make a large shoelace bow. Glue the bow to the front bottom of the wreath. Secure it with "U" pins.

3. Cut 18 inches (45 cm) of fall-leaf garland with wire cutters. Glue and pin one end of the garland to the wreath at the left side of the bow.

4. Continue gluing and pinning the garland to the front of the wreath until you reach the top.

5. Pin clumps of the moss around the bow and in two different places on the left side of the wreath.

6. Put the clay pots in the plastic bag and gently tap them with a hammer until they break roughly in half.

7. Glue the four pieces of the clay pots into the areas of moss, staggering and overlapping them for effect.

Sue's Tip

This is the perfect project to recycle those broken clay pots. Terra cotta clay gives your work a rustic look, making this wreath a wonderful gift for the gardener in your family. To increase the size of the design, simply use a larger straw wreath.

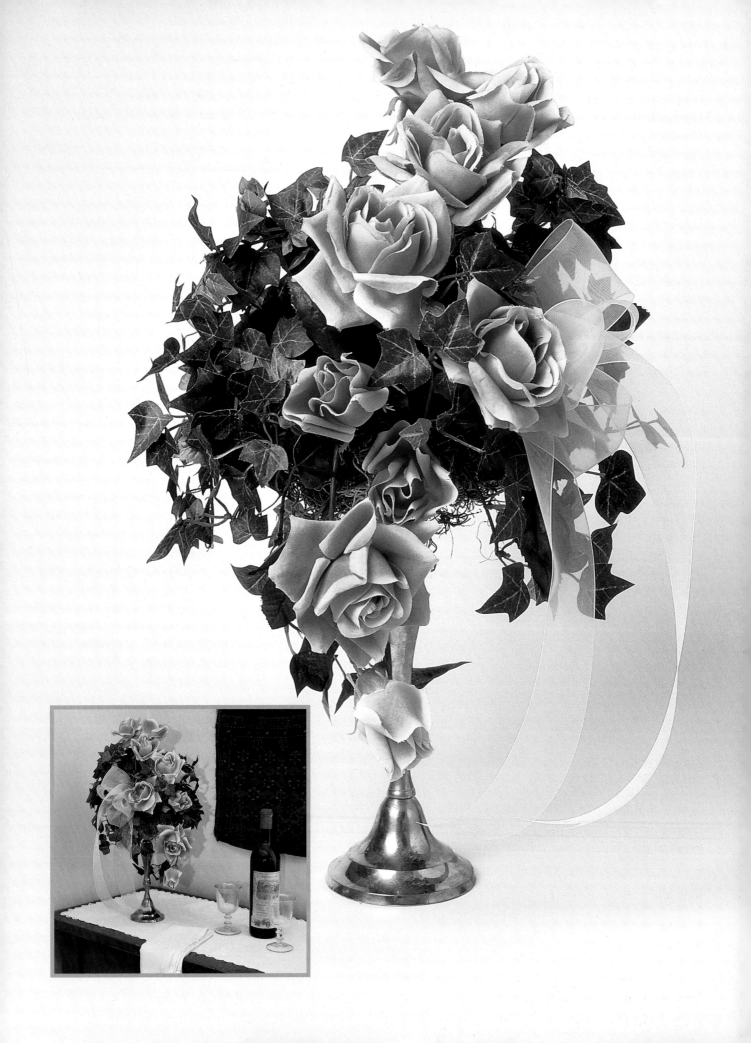

Floral Hogarth Curve

Materials

1 3-inch (7.5 cm) round Styrofoam disk
1 11-inch (27 cm) brass candlestick
1 small bag Spanish moss
1 small package floral "U" pins
1 medium silk ivy bush
9 medium single-stem dusty rose silk roses
2 yards (1.8 m) 3-inch (7.5 cm) Offray
 sheer ivory ribbon

Tools

glue gun with glue sticks
wire cutters
scissors

Instructions

1. Glue the foam disk securely to the top of the brass candlestick.

2. Cover the top and bottom of the disk with Spanish moss. Secure with "U" pins.

3. With the wire cutters, cut the two longest pieces of ivy from the bush. Shape the first piece in a curve. Insert and glue one end into the foam on the left side of the disk. Bend the ivy up to form a "C". Shorten it if necessary.

4. Repeat this process with the second piece of ivy on the right side of the disk, but curve it down to form a "C". The ivy should now form an "S" shape from the top of the first piece of ivy to the bottom of the second piece.

5. Cut the stems of three roses to 11 inches (27 cm), 10 inches (25 cm) and 9 inches (23 cm). Insert and glue the three rose stems into the left side of the foam disk beside the first piece of ivy. Stagger the flowers from longest to shortest. The roses should be side by side, with little space in between.

6. Cut the stems of the next three roses to 7 inches (18 cm), 5 inches (13 cm) and 4 inches (10 cm). Insert and glue the rose stems side by side in the middle of the arrangement, grouping them in a pleasing manner.

7. Cut the stems of the last three roses to 7 inches (18 cm), 5 inches (13 cm) and 4 inches (10 cm). Insert and glue the 7-inch (18 cm) rose stem in the right side of the disk, facing down, following the shape of the second piece of ivy. Moving up slightly, insert and glue the 5-inch (13 cm) rose stem on top of the 7-inch (18 cm) stem, also in a downward fashion. Lastly, insert and glue the 4-inch (10 cm) rose stem on top of the 5-inch (13 cm) rose stem so that the rose is facing downward.

8. If any rose does not look evenly placed, remove it, shorten the stem and glue it back in its original spot.

9. Fill the arrangement with more pieces of silk ivy, following the curve of the flowers and keeping the shape of the arrangement. Glue the ivy in place.

10. Tie a loopy bow with the sheer ribbon. Glue the bow into the front of the arrangement.

Sue's Tip

There are many different types of artificial or silk flowers, some more expensive than others. When you are choosing flowers for an arrangement, purchase the best quality you can afford. Remember, the arrangement will be around for many years; using good-quality products will never fail you.

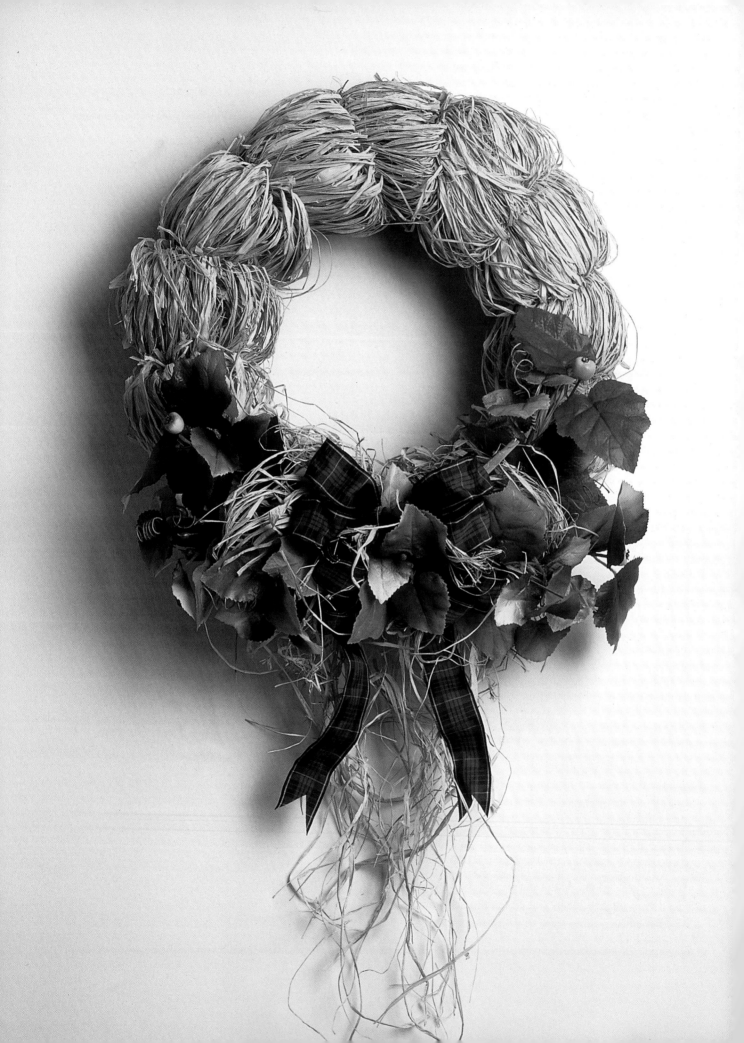

Nature's Delight Raffia Wreath

Materials

1 package natural raffia
1 paddle 24- to 26-gauge floral wire
1 raffia wreath
3 yards (2.75 m) 1½-inch (4 cm) Offray wired fall ribbon
1 silk fall-leaf bush

Tools

scissors
wire cutters
glue gun with glue sticks

Instructions

1. Tie a chunk of the raffia into a large bow and wire it to the bottom of the wreath.

2. Make a multi-loop bow with the fall ribbon, wiring the center securely. Wire this bow to the middle of the raffia bow.

3. Tie another loopy raffia bow and glue it to the middle of the ribbon bow.

4. With the wire cutters, cut the silk fall-leaf bush apart, leaving the stems approximately 6 to 8 inches (15 to 20 cm) long. Insert and glue the leaf stems into the wreath, working from the sides of the bow out, keeping both sides even.

5. Insert and glue one piece of the leaf stem into the middle of the bow.

Sue's Tip

The most refreshing part of this wreath is the wreath itself. It takes so little to decorate a raffia wreath, given the charming shape and design. Look around for other interesting raffia products, such as braids, which look great embellished and hung in the kitchen.

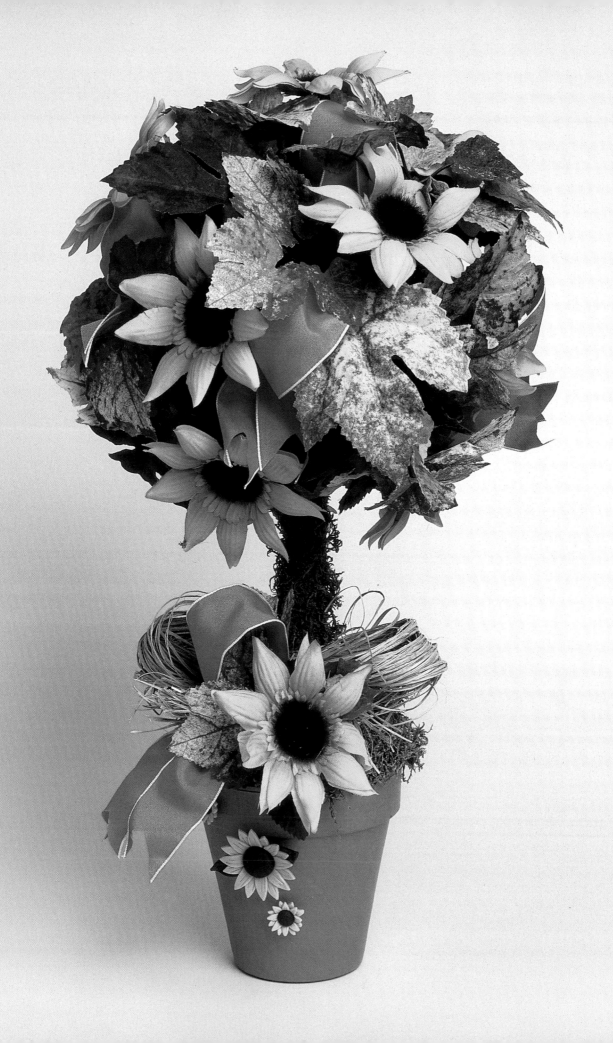

Sunflower Topiary

Materials

2 4-inch (10 cm) Styrofoam balls
1 4-inch (10 cm) clay pot
1 bag Spanish or green moss
1 small package floral "U" pins
1 new lead pencil
2 large silk sunflower bushes
1 silk fall-leaf bush
3 yards (2.75 m) 1½-inch (4 cm) Offray
 wired ribbon
1 small raffia bow
4 to 5 small resin sunflowers or colorful
 buttons

Tools

glue gun with glue sticks
wire cutters
scissors

Instructions

1. Push one of the Styrofoam balls snugly into the clay pot. Cover the top of the ball with the moss. Glue and pin the moss in place.

2. Glue the moss to the entire second Styrofoam ball and to the pencil, except the ends.

3. Insert one end of the pencil into the Styrofoam ball in the pot and the other end into the second Styrofoam ball. Glue the pencil in place.

4. Using the wire cutters, cut the two sunflower bushes apart, leaving the sunflower stems approximately 3 inches (7.5 cm) long.

Sue's Tip

Sunflowers never seem to go out of style. Their sunny disposition is always pleasing.

For the base of a larger topiary, you can use sticks and branches that have fallen from trees. For this size of tree, however, the pencil works well.

5. Insert and glue the stem of one flower at the top of the second ball and the stems of two other flowers on each side. Insert and glue more flowers to fill in the other areas, keeping the placement even.

6. Using the wire cutters, cut the fall-leaf bush apart. Insert and glue small stems of the bush to fill in the remaining open areas of the second ball, including the underside.

7. With the wired ribbon, make ten loopy bows. Glue nine of these bows throughout the topiary.

8. Glue the raffia bow to the base of the pencil. Insert and glue a small group of silk leaves around the raffia bow. Glue the tenth loopy ribbon bow to the front of the raffia bow.

9. Glue the small resin sunflowers or buttons to the pot to decorate.

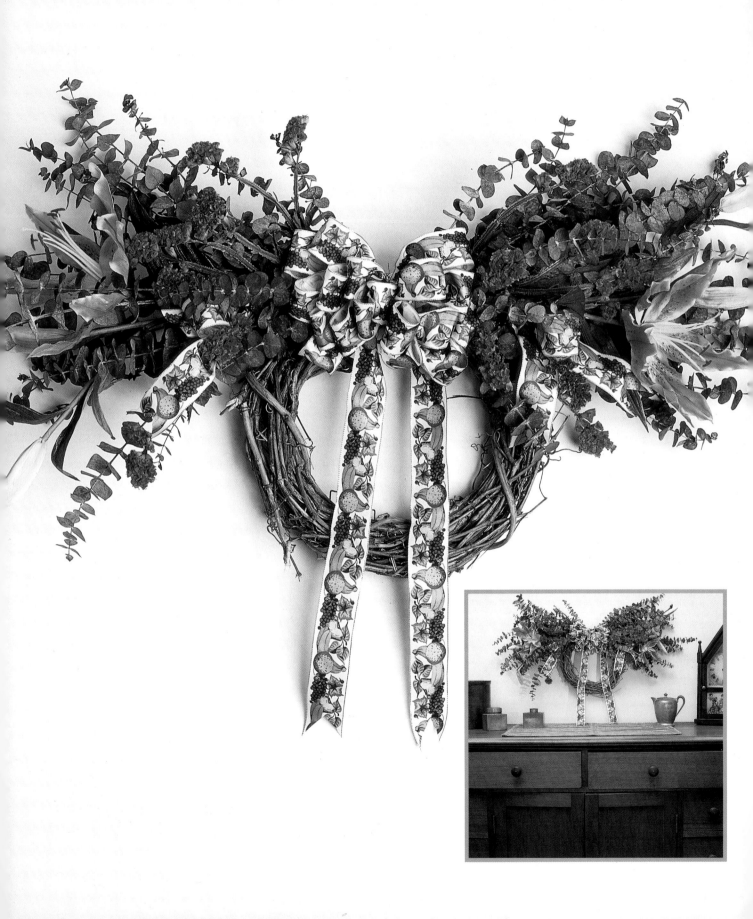

Silk Swag

Materials

1 large package green eucalyptus boughs
1 paddle 24- to 26-gauge floral wire
1 10-inch (25 cm) grapevine wreath
4 yards (3.65 m) 1½-inch (4 cm) Offray
 wired ribbon
Winward Silk Flowers:
 2 stems rubrum lilies
 3 to 4 stems German statice

Tools

wire cutters
glue gun with glue sticks
scissors

Instructions

1. Divide the eucalyptus boughs into long, medium and short stems.

2. Lay half the long stems to one side and half to the other. Cover the long stems with the medium ones.

3. Wire the two halves together in the middle, overlapping the stems to create the swag.

4. Wire the eucalyptus swag to the top of the grapevine wreath.

5. Make a multi-loop bow with the ribbon, being careful not to handle it too much. Wire the bow to the middle of the eucalyptus swag.

6. Cut the stems of the lilies approximately 8 inches (20 cm) long. Insert one lily in each side of the swag. Glue them in place.

7. Cut all statice stems apart. Insert and glue pieces of statice on both sides of the swag.

8. Make two short loopy bows with the ribbon. Insert and glue these bows on either side of the large bow.

9. Glue a few short pieces of the eucalyptus into the bow so that they poke upward from the bow to balance the swag.

Sue's Tip

If you want to vary this swag a little, add a bird nest to the grapevine wreath. Glue a little artificial "mushroom" bird into the nest. Or use your imagination. It doesn't take much to add that final personal touch to your work!

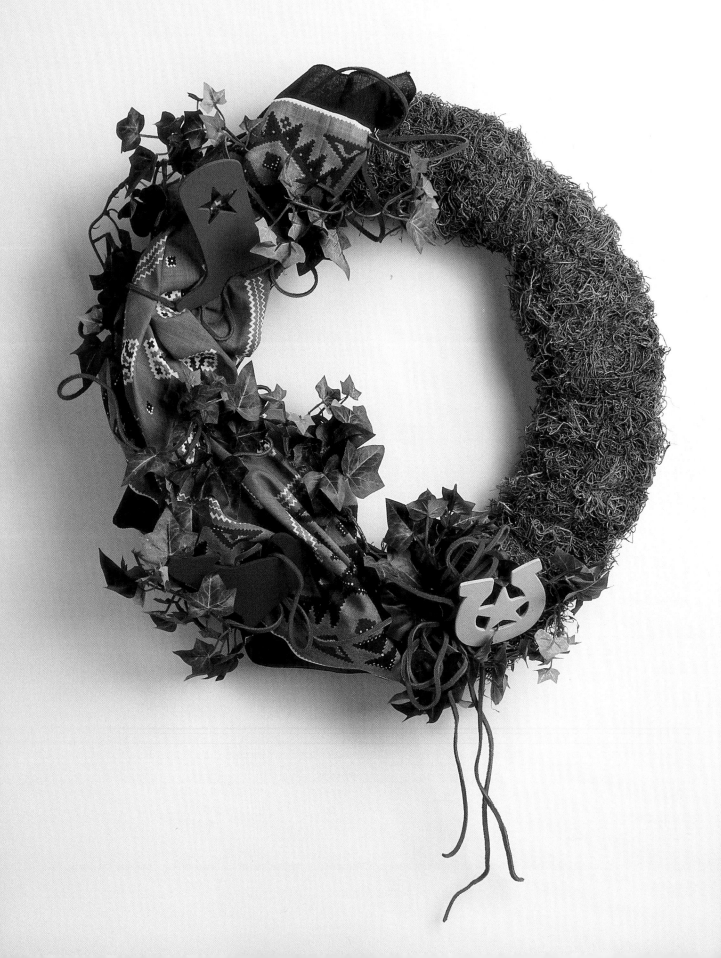

Southwest Moss Wreath

Materials

1 Craftable Bandanna to match paint colors
1 18-inch (45 cm) Spanish moss wreath
1 small package floral "U" pins
1 package light-rust suede lace
Americana acrylic paint:
 1 bottle Williamsburg Blue
 1 bottle Red Iron Oxide
 1 bottle Antique White
1 package pre-cut "western" wooden shapes
1 medium silk ivy bush

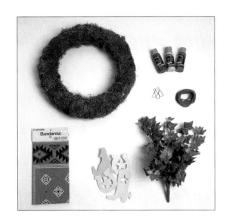

Tools

glue gun with glue sticks
small foam paint brush
water container
scissors
wire cutters
paper towel

Instructions

1. Place one corner of the bandanna at the upper left side of the wreath. Using the "U" pins, attach the bandanna loosely down and across the bottom of the wreath. Pinch and puff the bandanna as you go. Apply a little glue to the ends of the pins to secure them to the wreath.

2. Repeat the process with the suede lace, looping and pinning it in place. When you get to the bottom of the wreath, make a big loopy suede lace bow and secure it with a pin.

3. Using the small foam paint brush, apply one coat of paint to the front and back of the wooden shapes, varying the colors. Let the paint dry. Apply another coat if needed.

4. With the scissors, poke several small holes through the bandanna where you think you might like some greenery.

5. With the wire cutters, cut the silk ivy bush apart. Insert and glue several pieces of the bush through the holes in the bandanna and into the moss wreath, being careful not to cover too much of the bandanna. Insert and glue some more of the greenery around the top and bottom of the bandanna.

6. Glue the wooden shapes around the ivy, angling them to give the wreath dimension.

Sue's Tip

Colorful bandannas can be used in so many ways! To give your decor a little southwestern flair, put this wreath in your kitchen. Add napkins made from bandannas to the kitchen table and possibly a tablecloth designed from many bandannas sewn together in a patchwork fashion.

Floral Grapevine Grouping

Materials

1 paddle 24- to 26-gauge floral wire
3 6-inch (15 cm) grapevine wreaths
1 package Spanish moss
4 yards (3.65 m) 1¹/₂-inch (4 cm) Offray
 sheer ribbon
1 medium silk ivy bush
Winward Silk Flowers:
 3 stems peonies
 2 stems German statice
1 package Sheldricks dyed peppergrass

Tools

glue gun with glue sticks
wire cutters
scissors

Instructions

1. Wire the grapevine wreaths together to form a triangle.

2. Glue the Spanish moss in the area where the wreaths meet.

3. Make a soft, multi-loop bow with the sheer ribbon using a figure eight method. Wire the center of the bow securely, allowing the tails to flow freely.

4. Glue the bow in the middle of the Spanish moss.

5. With the wire cutters, separate the ivy bush. Wrap the ivy stems around all three grapevine wreaths, moving out from the bow.

6. Cut the leaves from the stems of the peonies. Cut the stems to approximately 3 inches (7.5 cm) long.

7. Insert and glue one flower to the left side of the bow, one to the right side of the bow and the third toward the top of the arrangement.

8. Cut the German statice stems apart. Place one stem flowing up from the bow and bending at the top, a second stem flowing up but staggered a little lower, the third stem flowing down from the bow and curving and the fourth stem a little higher and staggered again. Once you are satisfied with the look, trim the stems and glue them in place.

9. Glue small pieces of the peppergrass as filler throughout the arrangement.

10. Glue small pieces of ivy throughout the middle of the arrangement to soften and finish the look.

Sue's Tip

Here is a fast lesson on making those loopy bows. Start by making a loop on each side of your thumb and forefinger. Continue making loops until you have the number you want. You will be able to decide simply by looking at the bow. For a ten-loop bow, make five loops on each side. Wrap the center with wire to secure it. Trim the wire ends and the ends of the ribbon and you are finished.

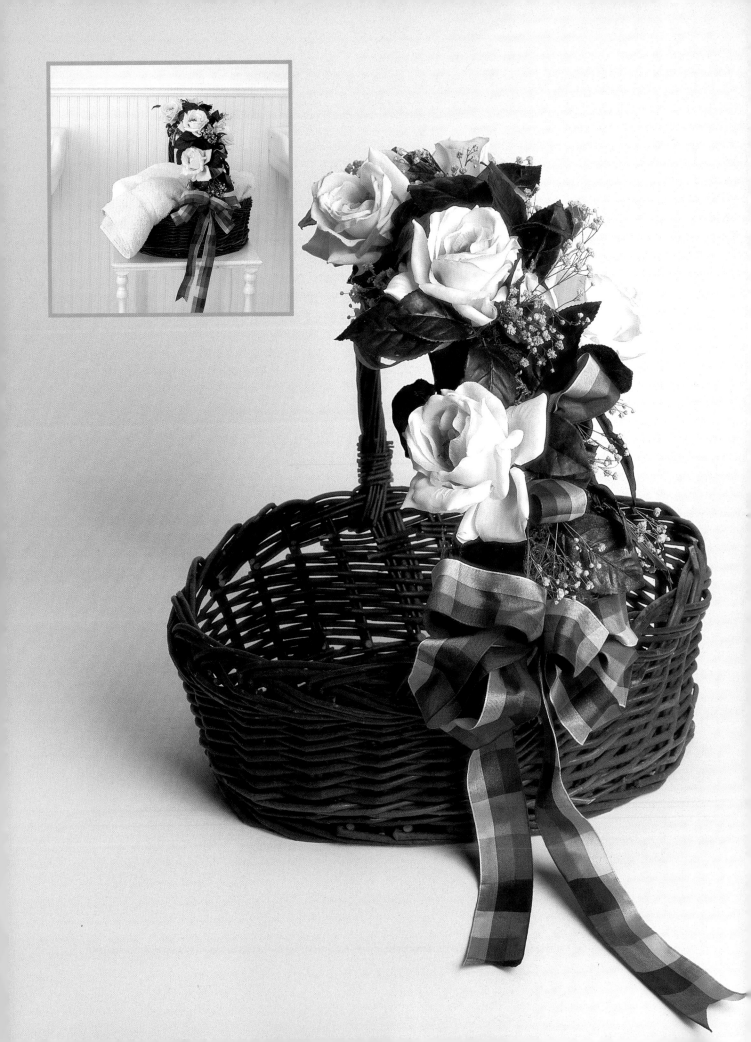

Easy Rose Basket

Materials

1 bag green moss
1 medium-sized brown basket with handle
4 yards (3.65 m) 1½-inch (4 cm) Offray spring ribbon
1 paddle 24- to 26-gauge floral wire
5 large Winward Silk ivory roses
1 package Sheldricks natural gyp

Tools

glue gun with glue sticks
wire cutters
scissors

Instructions

1. Glue the moss up one side of the basket and across the handle.

2. Make a multi-loop bow with 3½ yards (3.2 m) of ribbon and wire it tightly to the base of the handle. Secure the bow further by gluing it to the basket.

Sue's Tip

Baskets are not only attractive, they are functional. Use them to hold that collection of magazines, or maybe those extra towels in the bathroom or powder room. Small baskets serve as containers for cotton balls in the bathroom, or in the kitchen for cutlery or napkins. Take a look around at garage and antique sales. You can often find a basket or two that simply requires sprucing up with a few coats of spray paint.

3. Cut the leaves from the rose stems and set them aside. Cut the rose stems to approximately 3 inches (7.5 cm) long.

4. Insert and glue the roses evenly into the moss across the handle of the basket. Further secure the stems by wiring them to the handle.

5. Glue the leaves all through the moss, flowing out from the roses.

6. Fill in the rest of the open spaces on the handle with small groupings of the natural gyp.

7. Cut the remaining ½ yard (45 cm) of ribbon into several pieces. Make small loops and glue them around the roses.

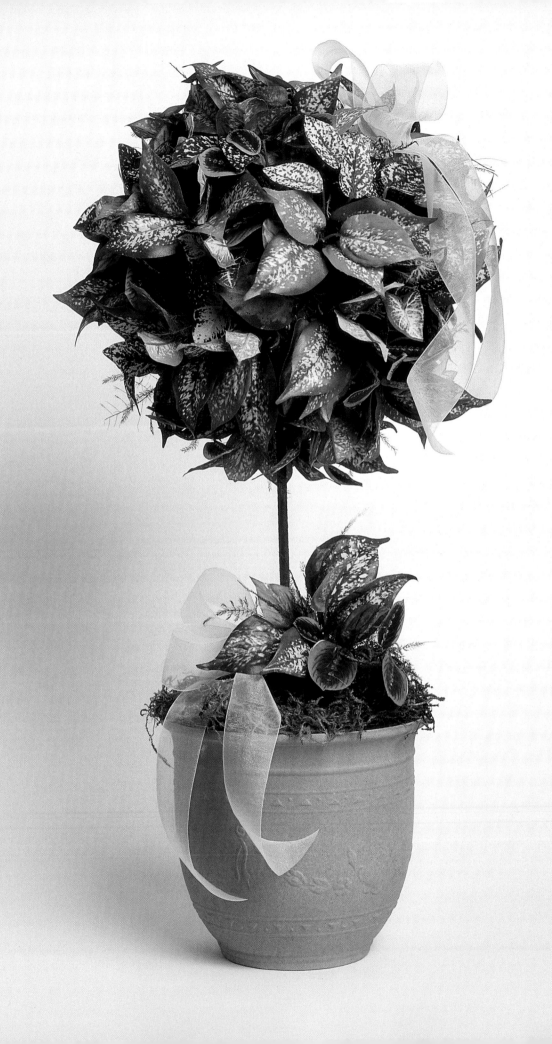

Greenery Topiary

Materials

1 large block sahara floral foam
1 soft-green decorative pot 6 inches
 (15 cm) high and 6 inches (15 cm)
 in diameter (see note)
1 bag green moss
1 small package floral "U" pins
1 6-inch (15 cm) Styrofoam ball
1 package 16-gauge floral wire
1 roll green floral stem wrap
12 to 14 silk greenery picks
1 package Sheldricks preserved fern
2 yards (1.8 m) 3-inch (7.5 cm) Offray lemon-yellow sheer ribbon

Tools

small floral knife
scissors
glue gun with glue sticks
wire cutters

Instructions

1. With the floral knife, cut the floral foam to fit snugly inside the pot. Glue the foam into the pot.

2. Cover the foam with moss. Pin it in place.

3. Cover the Styrofoam ball with moss, pinning it in place.

4. In one hand, hold the entire package of 16-gauge wire. With the other hand, begin wrapping the floral stem wrap around the wires, starting at the top and winding the wrap down around the wires. Pull the tape as you go to release the gum. The tape will adhere to itself. This forms your stem.

5. Insert the stem into the foam in the pot until it touches the bottom. Glue it in place.

6. Place the Styrofoam ball on the top of the stem, pushing it down gently until the stem comes slightly through the top of the ball. Glue the ball in place.

7. With wire cutters, separate all the greenery picks. Insert and glue the greenery pieces into the Styrofoam ball until the ball is almost, but not completely, covered.

8. Insert and glue a few pieces of greenery into the moss around the base of the stem.

9. With wire cutters, cut the preserved fern into small pieces. Insert and glue the pieces amid the greenery on the ball and at the base of the stem.

10. Pin small pieces of moss in and around the greenery and fern on the ball.

11. Divide the ribbon in half. Make two loopy bows. Attach one to the greenery ball and the second to the base of the stem.

Note: If you can't find a soft-green decorative pot, spray a 6-inch (15 cm) clay pot with white spray primer. Allow the primer to dry. Water down a small amount of light-green acrylic paint, and using a soft cloth, wipe a wash of the green over the pot. Allow the paint to dry completely.

Sue's Tip

For a different "trunk" for a topiary tree, use an attractive twig or a piece of dowel painted green or covered with the floral stem wrap. Either of these will give you a good, sturdy topiary stem.

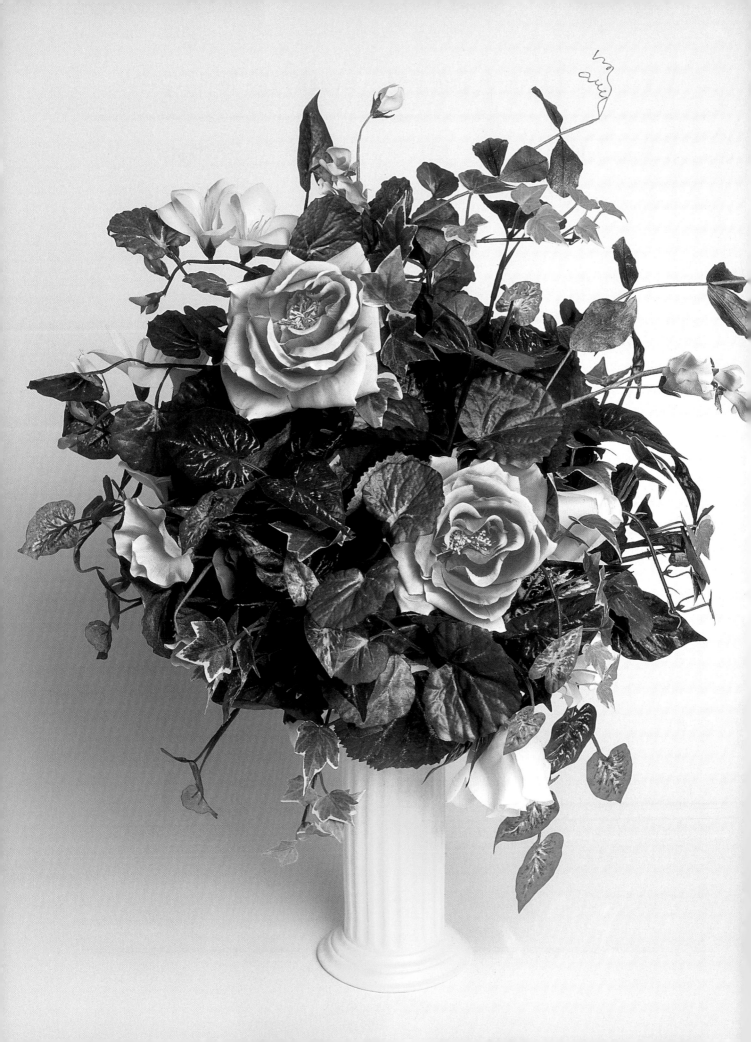

Pedestal Floral Arrangement

Materials

1 8-inch (20 cm) ceramic pedestal (shown painted)
1 can Krylon white spray primer
DecoArt Patio Paint:
 1 bottle Sunshine Yellow
1 small block sahara floral foam
3 different silk greenery bushes
1 small package 6-inch (15 cm) wooden floral picks
1 roll green floral stem wrap

Winward Silk Flowers:
 1 stem sweetpea
 2 stems large roses
 3 stems rosebuds
 1 stem freesia

Tools

medium foam paint brush
water container
paper towel
glue gun with glue sticks
wire cutters
scissors

Instructions

1. Spray the pedestal with the white spray primer and allow it to dry completely.

2. With the foam paint brush, apply two coats of the yellow Patio Paint. Allow the paint to dry completely after each coat. Glue the floral foam to the top of the pedestal.

3. With wire cutters, cut the stems of the first greenery bush apart. Insert and glue stems into the foam. Allow stems to drape down the front of the pedestal.

4. Cut the stems of the second bush apart. Insert and glue one of the longer stems into the middle of the arrangement. This piece should be approximately 14 inches (35 cm) high.

5. Continue to insert and glue stems of the second bush into the foam, creating a cone shape with the widest area of the arrangement measuring approximately 12 inches (30 cm) across.

6. Cut the stems of the third bush apart. Insert and glue the stems into the foam, working more greenery into the arrangement to fill the body. Keep the cone shape at all times. If you need to lengthen any of the stems, attach a wooden floral pick with stem wrap.

7. With wire cutters, cut the sweetpea stem apart. Insert and glue the longest part of the stem into the middle of the arrangement. The top of the flower should protrude only slightly above the greenery.

8. Cut one of the large silk rose stems 8 inches (20 cm) long. Insert and glue the rose into the arrangement close to the middle. Cut the second rose stem 3 inches (7.5 cm) long. Insert and glue this stem to one side.

9. Cut the stems of the silk rosebuds to 3 inches (7.5 cm), 4 inches (10 cm) and 5 inches (13 cm). Insert and glue the rosebuds so that they hang over the right edge of the pedestal.

10. Fill the arrangement in with pieces of freesia, remaining sweetpea stems, and any greenery you have left.

Sue's Tip

Keep contrast in mind when floral arranging. White and yellow add pretty highlights to dark arrangements. Greenery, on the other hand, gives great depth to brightly colored designs. Unusual shapes add interest, and finishing off with ribbon shows true inspiration!

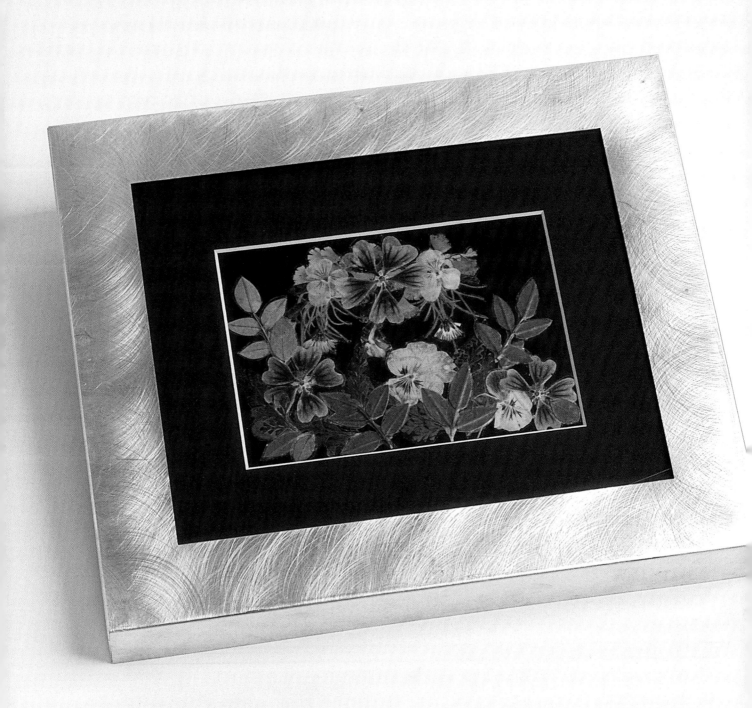

Botanical Box Frame

Materials

1 Framer's Gallery aluminum box frame
 (any size)
1 picture frame mat to fit box frame
15 dried leaves and flowers (see note) OR
 1 package Distinctions in Nature
 botanical pressed flowers

Tools

pencil
scissors
white glue
tweezers

Instructions

1. Open the box frame and remove the inside black box. Place the picture frame mat on the flat front surface of the box and mark the inside rectangle of the mat with a pencil. Remove the mat and set it aside.

2. Place the dried flowers and leaves within the marked rectangle of the box, trimming them and moving them around until they create a pleasing pattern or picture.

Sue's Tip

Instead of using a picture frame mat, you can use fast-drying Design Master spray paint to change the color of the inside box. Apply two or three coats of paint, allowing drying time between coats. Follow the same directions to arrange and glue your flowers.

3. Apply a tiny dot of glue to the back of each flower and leaf in turn and use the tweezers to return them to their places. Allow the glue to dry. If you are using the Distinctions in Nature pressed flowers, follow the directions on the package to adhere the design.

4. Place the mat, colored side down, into the aluminum frame. Insert the box into the aluminum frame, flower side down.

Note: To press botanicals, choose several leaves and flowers from your garden. Place them between the pages of a book and allow them to dry thoroughly.

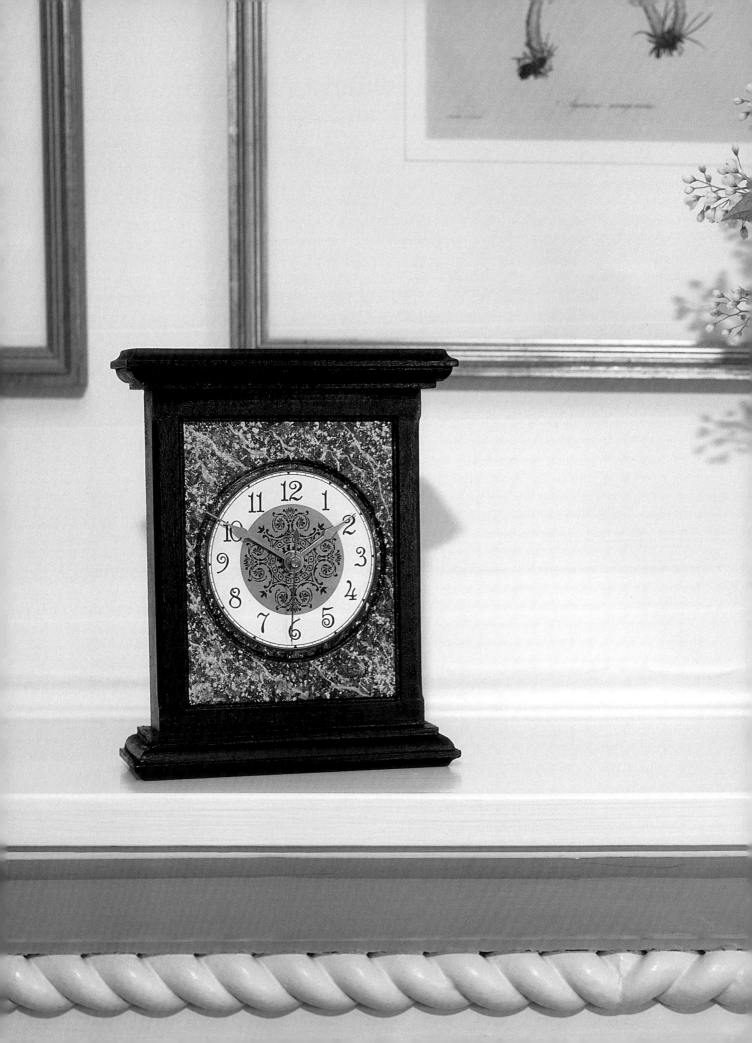

The Painted Pro

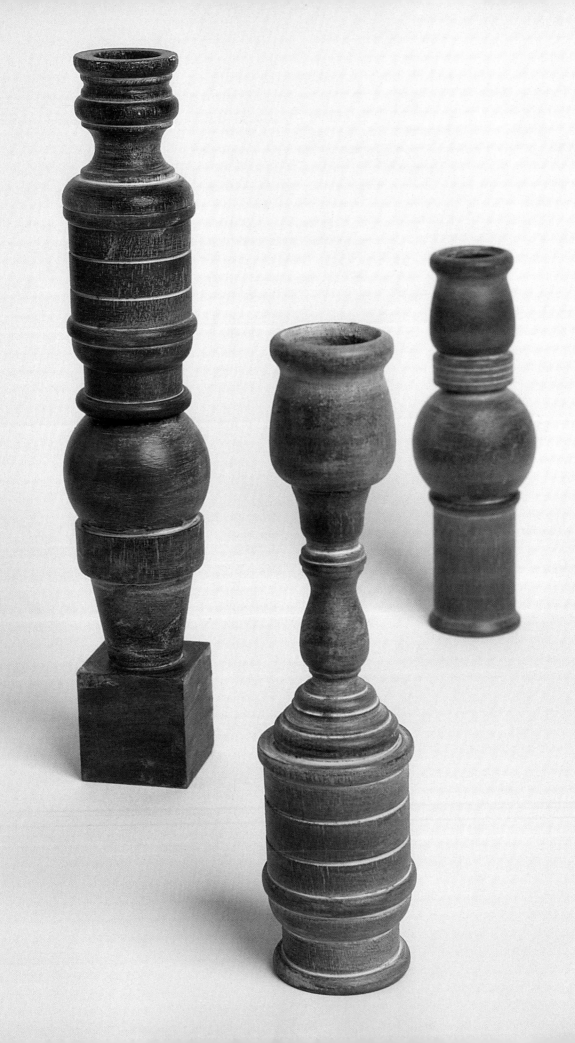

Antiqued Candlesticks

Materials

assorted Tolin' Station wooden pieces:
- toothpick holders
- large wooden knobs
- doll pin stands
- small and large wooden blocks
- stamp boxes
- wooden spools
- small flower pots
- large candle cups

Plaid Faster Plaster acrylic paint:
- 1 tub Country Blue
- 1 tub Christmas Green
- 1 tub Country Burgundy

Folkart acrylic paint:
- 1 bottle Ivory White

1 small bottle Folkart satin acrylic varnish

Tools

Aleene's Designer Tacky Glue
small foam paint brushes
water container
paper towel
soft cloth
craft stick

Instructions

1. To design your candlesticks, arrange several wooden pieces on top of each other to form interesting designs. Place the larger, more stable pieces on the bottom to ensure that the candlestick is not top heavy. As the top piece, always use a large candle cup.

2. Using a craft stick, glue the pieces together with a small amount of glue. Allow the glue to dry overnight.

3. Paint the candlesticks with the three colors of acrylic paint. Vary the colors. Apply a second coat if necessary once the first coat is dry. Allow the paint to dry completely.

4. Dilute the ivory paint $\frac{1}{3}$ water to $\frac{2}{3}$ paint. Working in small areas at a time, apply a coat of the diluted paint to each candlestick. Wipe the ivory paint off as you go, leaving a whitewashed effect. Allow the paint to dry.

5. With a foam paint brush, apply two thin coats of satin acrylic varnish. Allow each coat to dry completely.

Sue's Tip

Check your candlesticks as they dry. Sometimes the wooden pieces will shift and need to be adjusted.

There are many acrylic paints on the market today. Some require only one coat, while others require two or three. Simply allow drying time after each coat.

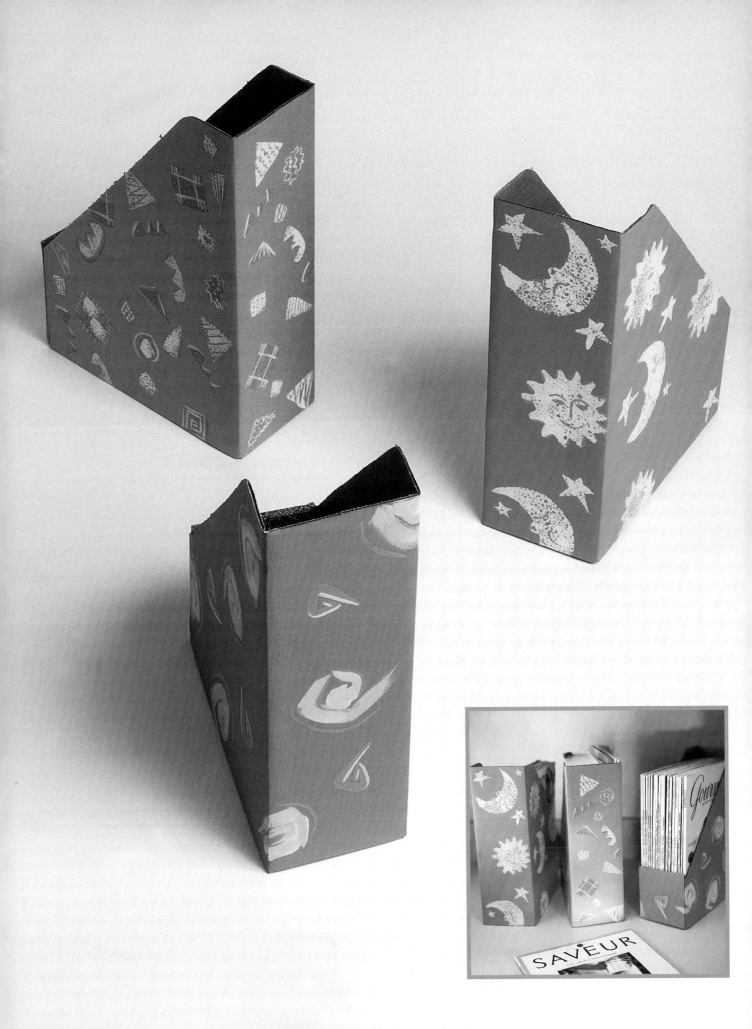

Magic Magazine Boxes

Materials

3 cardboard magazine boxes
Americana acrylic paint:
 1 bottle Pumpkin
 1 bottle Country Blue
 1 bottle Primary Yellow
Optional stencils

Tools

large foam paint brush
water container
small flat paint brush
paper towel
stencil spouncer
stencil tape

Instructions

1. Using the orange paint and the large foam paint brush, paint the entire outside of one of the magazine boxes. Apply a second and third coat, allowing to dry between coats.

2. With the small flat paint brush, try your hand at some free-form painting. You might choose a geometrical design or perhaps a celestial pattern.

3. If you are more comfortable using a stencil, position the stencil on the box where you want your design. Tape the stencil in place.

4. Dip the stencil spouncer into the acrylic paint. Blot the excess paint on the paper towel. Apply the paint to the stencil in an up-and-down pouncing manner.

5. Remove the stencil and allow the paint to dry. Repeat this process as many times as it takes to complete your pattern.

6. Repeat the process with the other boxes. Mix up the colors.

Sue's Tip

I enjoy using a free-form painting style. There is no worry about straight lines or whether my stars and moons are perfect. The uneven lines and patterns add to the charm of the piece. Let the kids get involved in making these wonderful boxes. They might just keep their rooms a little tidier!

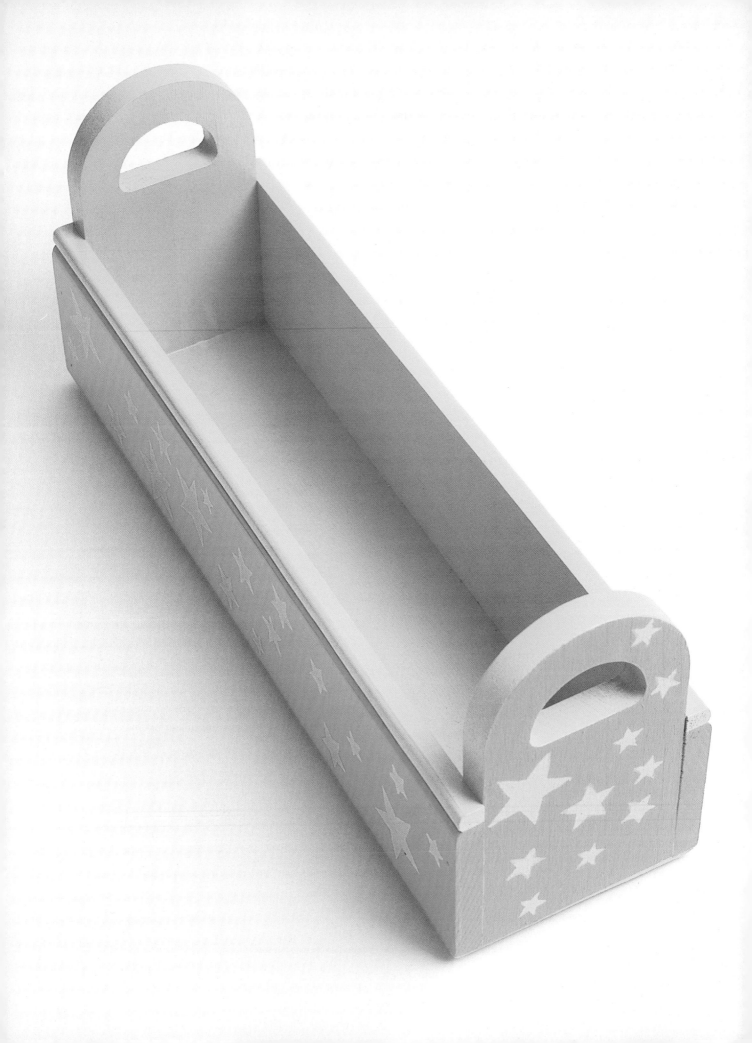

Star Planter

Materials

1 Walnut Hollow wooden planter box
1 small bottle Americana matte acrylic
 varnish
Americana acrylic paint:
 1 bottle Cadmium Yellow
 1 bottle Bright Green
1 roll adhesive back shelf liner
1 star-shaped stencil
1 can Illinois Bronze Crystal Clear glaze

Tools

fine grit sandpaper
paper towel
medium foam paint brushes
water container
scissors
tweezers

Instructions

1. Sand the planter box well, removing any rough edges. Wipe the box with a damp paper towel to remove any dust.

2. With a medium foam brush, apply one coat of the matte acrylic varnish to the entire surface of the box, inside and out, to seal the wood. Allow the varnish to dry.

3. Apply two or three coats of yellow acrylic paint to the entire planter. Let it dry after each coat.

4. Trace and cut several star shapes in different sizes from the adhesive shelf liner. Remove the backing and stick the stars all over the sides of the box.

5. With a medium foam brush, apply one or two coats of green acrylic paint directly over the star shapes on the outside of the planter. Leave the inside of the planter yellow. Allow the paint to dry after each coat.

6. With tweezers, remove the star shapes from the sides of the box. The yellow paint underneath will show through and create a wonderful design.

7. In a well-ventilated area, apply two or three coats of the glaze. Let the box dry after each coat.

Sue's Tip

As cooler weather moves in, we may get a little melancholy at the sight of the last of the summer rays. Keep the flavor of summer in your house all year long with brightly colored planters potted with fragrant herbs that grow beautifully inside. To keep everything tidy and preserve the life of your planter, just be sure to insert a plastic liner into your containers before putting soil in them.

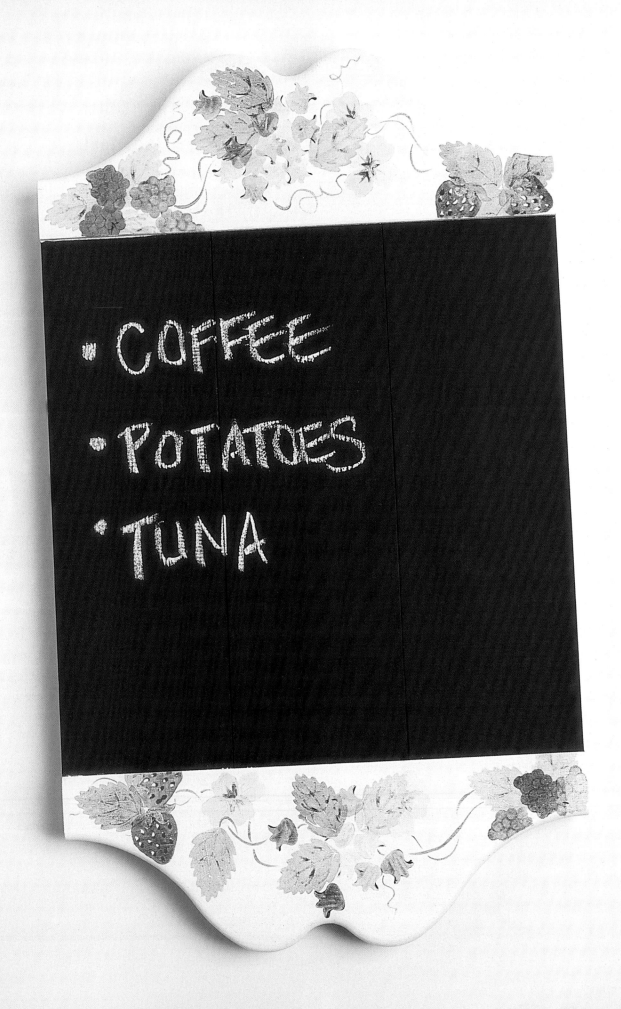

Handy Homemade Blackboard

Materials

1 large wooden sign board
1 can Krylon black spray primer
1 can black chalkboard paint
Folkart acrylic paint:
 1 bottle Wicker White
1 package Plaid mixed berries Decorator
 Blocks
Plaid Glazes:
 1 bottle Lemon Yellow
 1 bottle Christmas Red
 1 bottle Danish Blue
 1 bottle Alpine Green
1 small bottle Folkart gloss acrylic varnish

Tools

narrow painter's tape
medium foam paint brushes
small flat paint brush
water container
paper towel

Instructions

1. Tape the top and bottom edges of the sign board with painter's tape.

2. In a well-ventilated area, spray paint the flat front of the sign board with the black spray primer. Allow it to dry thoroughly.

3. With a medium foam brush, apply a coat of the chalkboard paint to the flat area of the board. Allow this coat to dry overnight. Apply a second coat, and again, allow it to dry thoroughly.

4. Remove the painter's tape. Apply two or three coats of white acrylic paint to the top and bottom areas of the sign board, being careful not to get any white paint on the black chalkboard area. Allow the paint to dry after each coat.

5. Following the instructions on the block printing package, use the flat brush to apply various colored glazes to print a design of mixed berries on the top and bottom of the board. Use your imagination and vary your design to suit your decor. Allow the glazes to dry.

6. With the medium foam paint brush, apply two or three coats of the acrylic varnish on the top and bottom areas of the board. Do not varnish the black chalkboard. Let the varnish dry after each coat.

7. Paint the back of the blackboard white.

Sue's Tip

Blackboards are so useful in all areas of your home. Try hanging a message board on your front door. Neighbors and delivery people will appreciate the opportunity to leave you a message if you're not home when they come by.

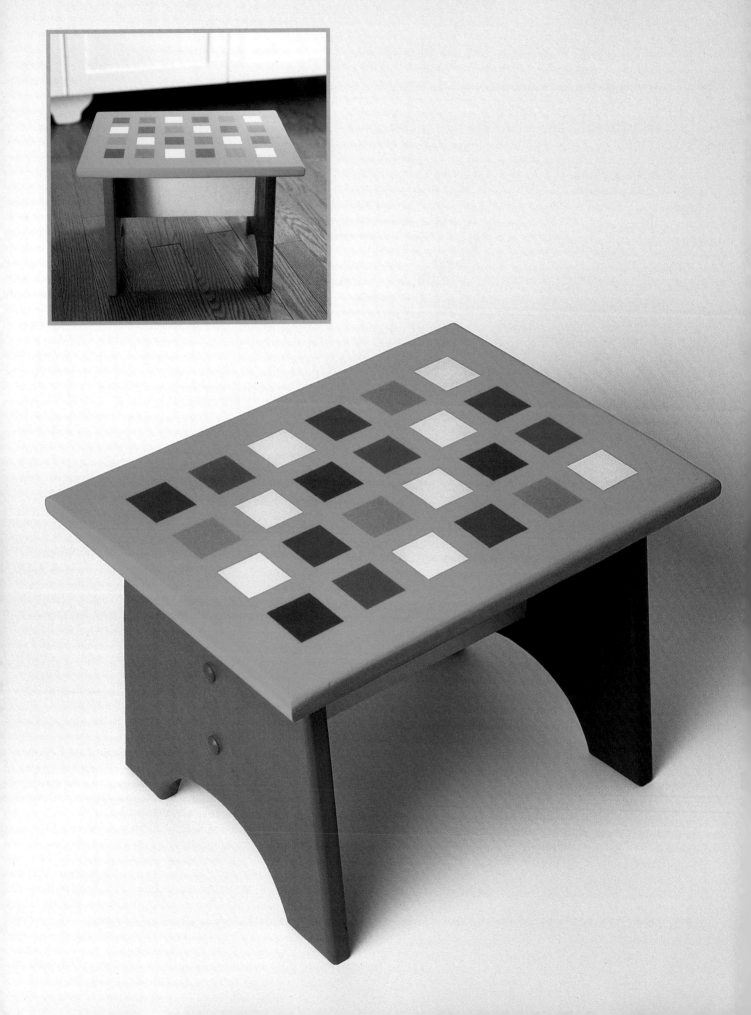

Funky Footstool

Materials

1 wooden footstool with flat top surface
1 can Americana matte acrylic sealer/
　　finisher spray
Americana acrylic paint:
　　1 bottle Holly Green
　　1 bottle Violet Haze
　　1 bottle Country Blue
　　1 bottle Primary Yellow
　　1 bottle Desert Turquoise
　　1 bottle Lavender

Tools

fine grit sandpaper
paper towel
large foam paint brush
small foam paint brush
water container
wide painter's tape
narrow stencil tape

Instructions

1. Sand the stool well, smoothing all rough edges. Use a damp paper towel to remove the dust.

2. Apply a coat of the sealer/finisher to seal the wood. Let it dry.

3. Paint the top and underside of the stool green. Let the paint dry thoroughly. Apply a second coat if necessary and let it dry.

4. Paint the right leg violet, the left leg blue and the bar in between the legs yellow. Allow all paint to dry and apply a second coat if necessary. Let the paint dry thoroughly.

5. Apply pieces of the wide painter's tape to the edge of the stool's top, forming a square.

6. Apply pieces of the narrow stencil tape vertically and horizontally to create a number of squares within the large square.

7. Paint the squares in alternating colors, varying the design as you go to form an attractive pattern. Be sure not to paint over your tape lines. Allow the paint to dry and repeat with a second coat if necessary.

8. When the paint is relatively dry, remove the tape gently to reveal your pattern.

9. Allow all paint to dry thoroughly and apply two or three coats of sealer/finisher, allowing drying time between each coat

Sue's Tip

These footstools make a great addition to a kid's room. They can also be used as little end tables. The design and colors you choose for the footstool can be carried into the decor of the room.

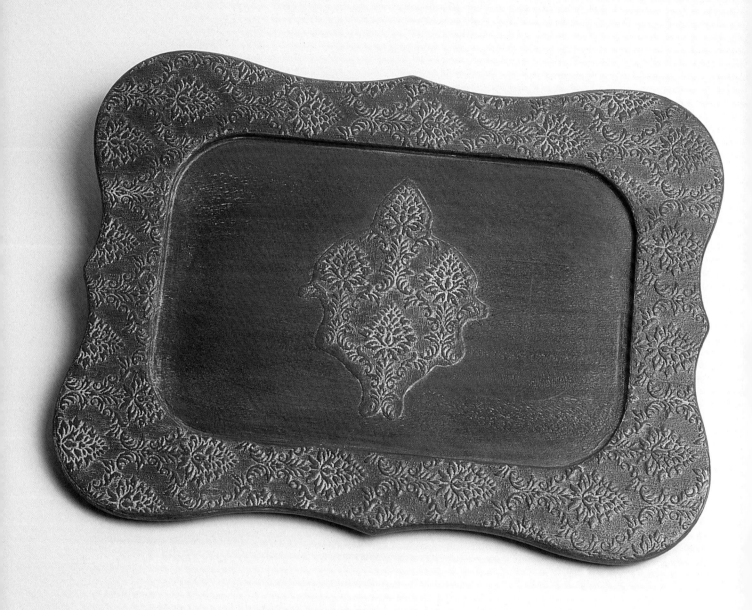

Faux Embossed Tray

Materials

1 Walnut Hollow wooden tray with raised edge
1 can Folkart Clearcote acrylic sealer spray
1 piece textured white wallpaper suitable for painting
Folkart acrylic paint:
 1 bottle Dapple Gray
Plaid Antiquing Wash:
 1 bottle Walnut Brown
 1 bottle Metallic Honey Gold
1 bottle Plaid White Liquid Chalk

Tools

fine grit sandpaper
paper towel
pencil
scissors
Aleene's Designer Tacky Glue
X-acto knife
large flat paint brushes
water container
soft cloth

Instructions

1. Sand the tray well, removing all rough edges. Remove dust with damp paper towel.

2. Apply a light mist of acrylic sealer to seal the wood. Let it dry.

3. Place the wallpaper right-side down. Place the tray upside-down on top. Trace the shape of the tray onto the back of the paper. Cut out the shape and trim to fit the front of the tray.

4. With your finger, apply a layer of glue to the raised portion of the front of the tray. Place the cut wallpaper carefully onto this area. Smooth all edges out. If any edges are not completely flat, apply a small amount of glue and flatten the edges down completely.

5. Cut the middle section of the wallpaper away from the tray by running the X-acto knife around the inner edge of the raised portion.

6. Cut a small design from the wallpaper and glue it in the middle of the tray. Let it dry overnight.

7. Gently sand the edges of the wallpaper to create a very smooth look.

8. With the large flat paint brush, apply two or three coats of the gray acrylic paint to the entire tray, letting the paint dry after each coat.

9. Spray a thin layer of brown antiquing wash on the front of the tray. Gently wipe away the excess with a soft cloth. Let the tray dry completely.

10. Repeat this process with the gold. If you find it easier, you can apply the washes with a brush instead of spraying them. Let it dry completely.

11. Repeat the process on the back and along the edges of the tray.

12. With the large flat paint brush, apply a coat of the liquid chalk to the front, working in small areas at a time. Wipe the excess away with a soft cloth. The chalk residue will stay in the cracks and crevices of the textured wallpaper. Let the chalk dry.

13. Repeat the process on the back and allow the tray to dry completely.

14. Spray the entire tray with two or three coats of acrylic sealer, allowing drying time after each coat.

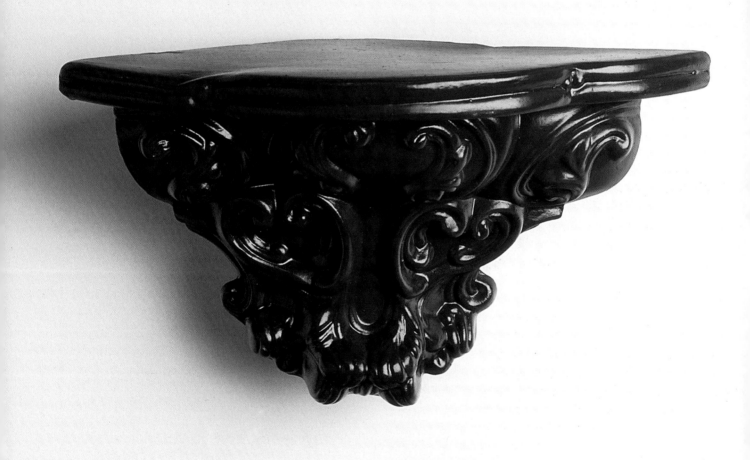

Leather-Look Wall Sconce

Materials

1 plaster wall sconce (shown painted)
Americana acrylic paint:
 1 bottle Terra Cotta
 1 bottle Georgian Clay
 1 bottle Burnt Umber
 1 bottle Honey Brown
1 can Americana matte acrylic sealer/
 finisher spray

Tools

fine grit sandpaper
medium flat paint brush
water container
paper towel
small flat paint brush
soft cloth

Instructions

1. With fine sandpaper, remove any rough edges, bumps or built-up areas on the plaster. Wipe away the dust with a damp paper towel.

2. Thin some of the Terra Cotta paint slightly with water. With the medium flat paint brush, paint a wash over the entire sconce. Continue to apply four or five thin layers of the same color, allowing each coat to dry before continuing with the next.

3. Repeat the process with the Georgian Clay paint, thinning it in the same manner.

4. Apply a thin wash of the Burnt Umber paint to cut down the red. Allow this coat to dry thoroughly.

5. With the small flat paint brush, apply the Honey Brown paint, diluted but thicker than the previous paint washes. Work it into the cracks and crevices. Wipe the excess off with the soft cloth as you go, leaving the color in the grooves. Let the paint dry completely.

6. Apply two or three coats of the sealer/finisher over the entire sconce, allowing it to dry after each coat.

Sue's Tip

Plaster and ceramic pieces are more attractive when the design is detailed and has lots of texture. Once you become proficient at building color, you will be able to create finished projects that your friends will think came from an expensive antique store.

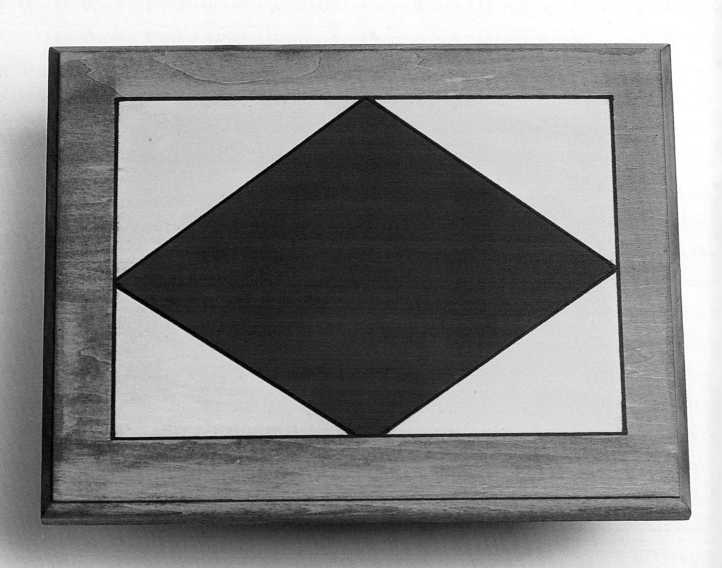

Block Stained Chargers

Materials

4 Walnut Hollow 9" x 12" (23 cm x 30 cm) wooden plaques
1 small bottle Americana matte acrylic varnish
Americana acrylic paint:
 1 bottle Forest Green
 1 bottle True Ochre
 1 bottle Deep Burgundy
1 medium-tip black permanent marker

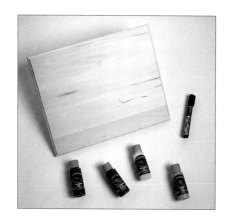

Tools

fine grit sandpaper
paper towel
small foam paint brushes
water container
pencil
ruler
painter's tape

Instructions

1. Sand the wooden plaques well, removing all rough edges. Wipe the plaques with a damp paper towel to remove any dust particles.

2. With a small foam brush, apply a coat of the acrylic varnish to seal the wood. Let it dry.

3. Make a small pencil mark 1 inch (2.5 cm) from the top middle edge of the plaque. Repeat this process on both sides and the bottom. Using a very light pencil line, connect the marks to form a 1-inch (2.5 cm) border.

4. Make a small pencil mark in the middle of each pencil line. With the ruler, join the marks together to form a diamond in the middle of the plaque.

5. Tape off the inside of the diamond.

6. Mix the green paint approximately half and half with water to create a stain. Dip the small foam brush into the green stain. Squeeze out most of the paint into the paper towel so you are using a practically dry brush. Brush the green stain around the outside edges of the plaque. Try to keep your strokes even and paint in the direction of the grain. Remove the tape and allow it to dry.

7. Tape off the green border and the inside diamond. Thin the ochre paint and apply it in the same manner, again blotting most of the paint out of the brush. Remove the tape and allow the yellow stain to dry.

8. Repeat the process for the inside diamond using the burgundy paint. Remove the tape and allow all the stain to dry thoroughly.

9. With a small foam brush, apply the green stain to the back of the plaque and let it dry completely.

10. With a ruler and black permanent marker, outline the design.

11. Repeat the process for the other three plaques.

12. With a small foam brush, apply two or three coats of acrylic varnish to all plaques, letting the varnish dry after each coat.

Sue's Tip

Chargers are fun and practical. They do not have to be round. Instead they can resemble a placemat. Use lots of different theme ideas to tie them into your decor. By incorporating latex paint, you can match them to your wall color and accessories.

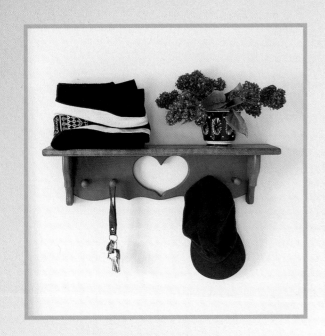

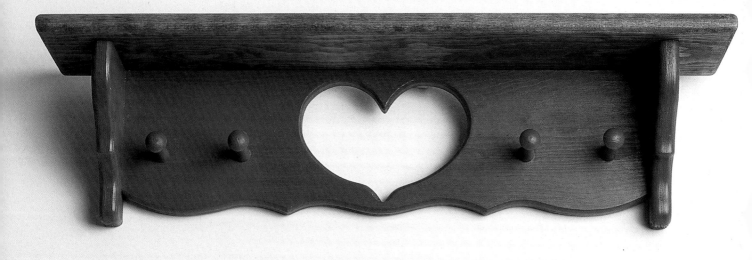

Traditionally Beautiful Shelf

Materials

1 large wooden shelf
1 can Step Saver walnut wood stain
Homestead acrylic paint:
　　1 can Bayberry
1 small bottle Americana satin acrylic
　　varnish

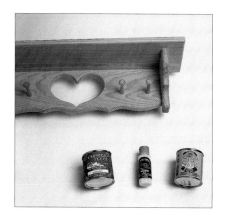

Tools

fine grit sandpaper
paper towel
medium foam paint brushes
water container
soft cloth

Instructions

Note: Complete this project in a well-ventilated area.

1. Sand the shelf to remove any rough edges. Remove all dust with a damp paper towel.

2. Following the instructions on the can of stain, use a medium foam brush to apply a coat to the top and underside of the shelf. This coat should be thick. Apply extra stain to dull spots.

3. Keep the surface wet with the stain for 15 minutes. Allow 30 minutes drying time then wipe off any excess stain. Allow the surface to dry completely.

4. Apply a second coat and allow it to dry thoroughly.

5. Following the instructions on the paint can, use a foam brush to apply two coats of the Bayberry to the lower half of the shelf. Allow the paint to dry after each coat.

6. With a medium foam brush, apply two or three coats of acrylic varnish, allowing the varnish to dry after each coat. You may want to apply an extra coat to the very top of the shelf to protect it from water marks and stains.

Sue's Tip

Milk paint is wonderful to work with and adds a soft and mellow look to your finished project. If you want to try it in this project, substitute it for the acrylic paint. However, make sure you work with a protective mask and be aware that milk paint is less opaque than acrylic paint.

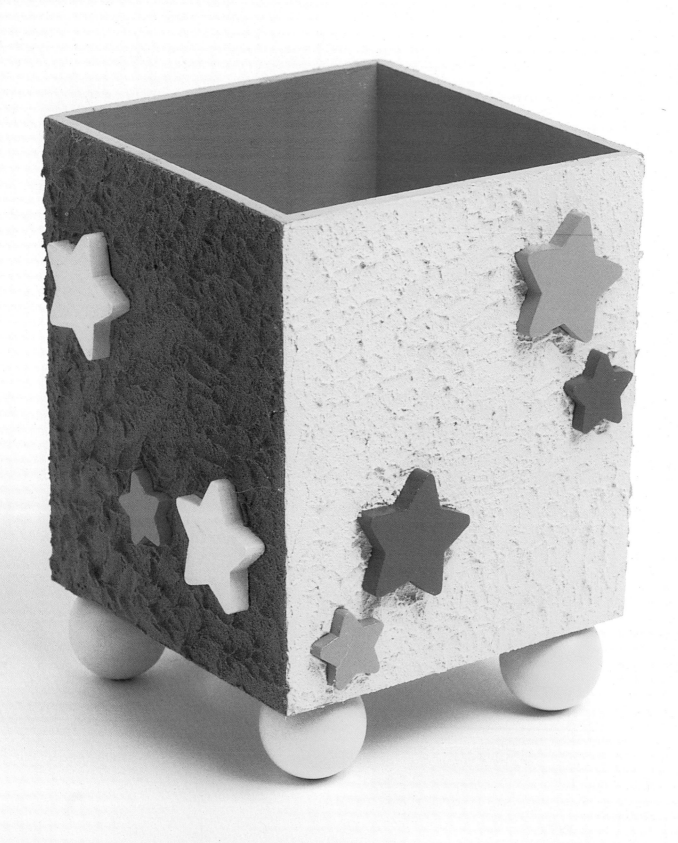

Tissue Box Planter

Materials

1 Walnut Hollow boutique tissue box
Liquitex acrylic paints:
 1 bottle Brilliant Orange
 1 bottle Cadmium Yellow
 1 bottle Medium Magenta
1 package small wooden stars
1 package medium wooden stars
2 packages 1¼-inch (3 cm) wooden knobs
1 jar Liquitex Ceramic Stucco texture gel
1 can Americana matte acrylic sealer/
 finisher spray

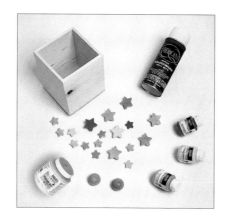

Tools

fine grit sandpaper
paper towel
medium flat paint brush
water container
small flat paint brush
palette knife
Aleene's Designer Tacky Glue

Instructions

1. Sand the inside and bottom of the tissue box until smooth. Wipe dust particles away with a damp paper towel.

2. Using the medium flat paint brush, apply two or three coats of orange paint to the inside of the box. Allow drying time after each coat. The box will be used upside down and therefore, the hole for the tissue will be the bottom of the planter. Wash and blot the brush dry.

3. Divide the package of medium stars into three groups. With the small flat paint brush, paint one group yellow, one group orange and one group magenta. Repeat the process with the small stars. Allow them to dry completely.

4. Paint four of the wooden knobs with two coats of the yellow paint. Allow drying time after each coat.

Sue's Tip

I have used very bright and intense colors for this project. Part of the intensity of the color comes from the "viscosity" of the paint. You can use any acrylic paints you wish, changing the colors to suit your own taste.

5. While the stars and knobs are drying, mix approximately half the jar of stucco with a very small amount of the yellow paint.

6. With the palette knife, apply the yellow stucco to two opposite sides of the tissue box. Keep your edges even and don't overlap the stucco onto the unpainted sides.

7. While the stucco is still wet, pounce on the stucco with the palette knife to create a raised effect. Press two medium magenta stars and two small orange stars onto the stucco. The stars will adhere to the stucco.

8. Repeat the process with the other two sides of the box, mixing half of the remaining stucco with orange paint and the other half with magenta paint. Apply the magenta to one remaining side and the orange to the other. Adhere the contrasting colored stars.

9. Turn the box upside down (the tissue box hole will be facing up) and glue the painted knobs to the corners of the box to create feet. Allow the planter to dry for approximately two days.

10. Spray two or three coats of sealer/finisher over the entire box. Allow drying time after each coat.

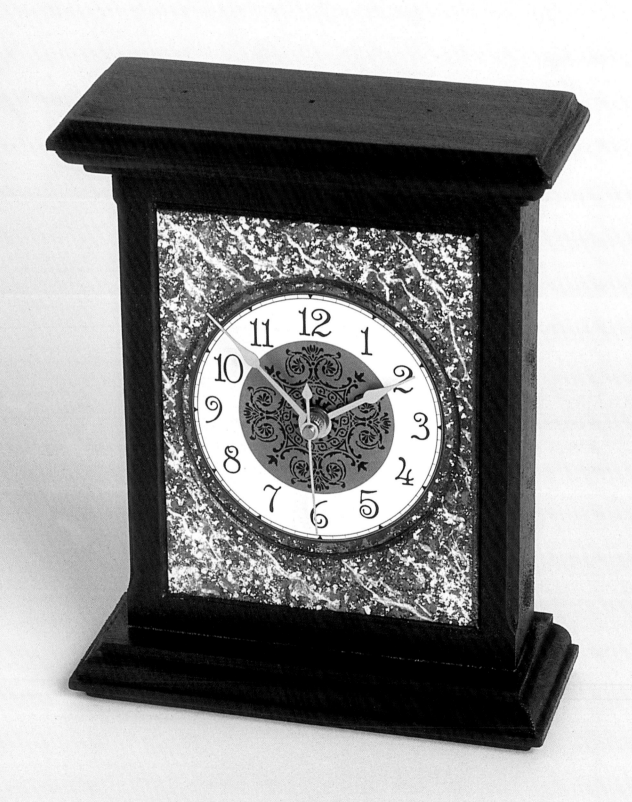

Easy Marbled Clock

Materials

1 Walnut Hollow carriage clock
1 small bottle Americana satin acrylic
 varnish
Americana acrylic paint:
 1 bottle Ebony Black
 1 bottle Forest Green
 1 bottle Deep Teal
 1 bottle Buttermilk
1 Walnut Hollow self-adhesive clock face
 (arabic $3\frac{1}{4}$-inch No. 1106)
1 Walnut Hollow clock movement
 (No. TQ500P)

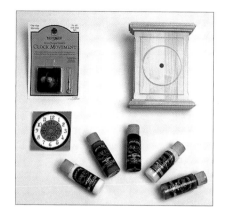

Tools

fine grit sandpaper
paper towel
small foam paint brushes
water container
painter's tape
small sea sponge
soft cloth
long feather

Instructions

1. Gently sand the clock, smoothing all rough edges. Wipe off loose dust with a damp paper towel.

2. With the small foam brush, apply a coat of acrylic varnish to seal the wood. Allow it to dry.

3. Paint the entire clock with two or three coats of the black paint. Allow the clock to dry after each coat.

4. Place a line of tape around the middle square of the front of the clock. Using a damp sea sponge, dab this middle area lightly with dark green paint. Be sure not to get any green outside the taped off section.

5. Lightly dab teal paint on top of the dark green.

6. Apply a very light dab of Buttermilk paint on top of the greens. Allow all paint to dry thoroughly.

7. Dilute some of the Buttermilk paint with water to an inky consistency. Run the feather through the paint and make light, feathery lines on top of the sponged area of the clock. Remove the tape. Let the paint dry.

8. Apply two or three coats of acrylic varnish to the entire clock. Allow it to dry after each coat.

9. Apply the self-adhesive clock face to the middle of the front of the clock.

10. Gently sand a layer of paint off the edges of the clock, creating a "distressed" look.

11. Following the directions on the package, assemble the clock movement.

Sue's Tip

There are many great ways to achieve a faux finish on your projects. This fast and easy marbling technique is just one of them. You can also drizzle the three paint colors, one on top of the other, and apply the marbled look with a sponge in one step. Experiment to find the technique that works best for you.

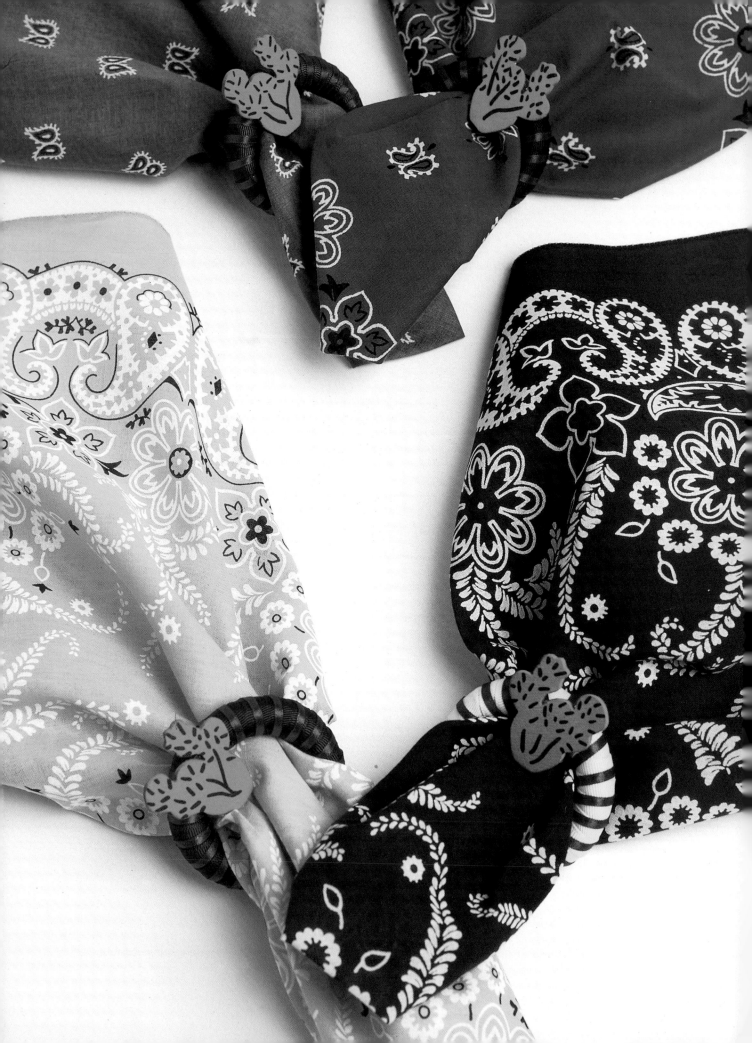

Fiesta Bandanna Napkin Rings

Materials

4 wooden rings 2¾" x 1¾" (7 cm x 4.5 cm)

Offray grosgrain ribbon:
- 2 yards (1.8 m) green
- 2 yards (1.8 m) yellow
- 2 yards (1.8 m) purple
- 2 yards (1.8 m) blue

1 narrow purple Offray Spool o' Ribbon

4 wooden cactus shapes (shown painted)

Folkart acrylic paint:
- 1 bottle Old Ivy
- 1 bottle Licorice

4 Craftable Bandannas:
- 1 dark green paisley
- 1 royal blue paisley
- 1 gold paisley
- 1 purple paisley

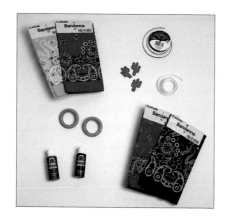

Tools

scissors

glue gun with glue sticks

paper towel

small flat paint brush

liner paint brush

water container

Instructions

1. Wrap each wooden napkin ring with a different color of grosgrain ribbon, overlapping the ribbon as you go. When you have completely covered a ring, glue the end of the ribbon in place.

2. Wrap the narrow purple ribbon over the grosgrain ribbon on all four napkin rings, leaving space between each wrap.

3. With the small flat paint brush, paint the front and back of all four wooden cactus pieces green. Let them dry.

4. With the liner brush, apply very narrow black lines to the cactus to create dimension.

5. Glue a cactus to the front of each napkin ring.

6. Slip a bandanna through each ring. Mix and match your colors.

Sue's Tip

Be creative when choosing a color scheme for your kitchen. Let nature's colors inspire you, or pull colors from a favorite rag rug or a simple print fabric. Carry these colors into your placemats and napkins.

Stencil
Magic

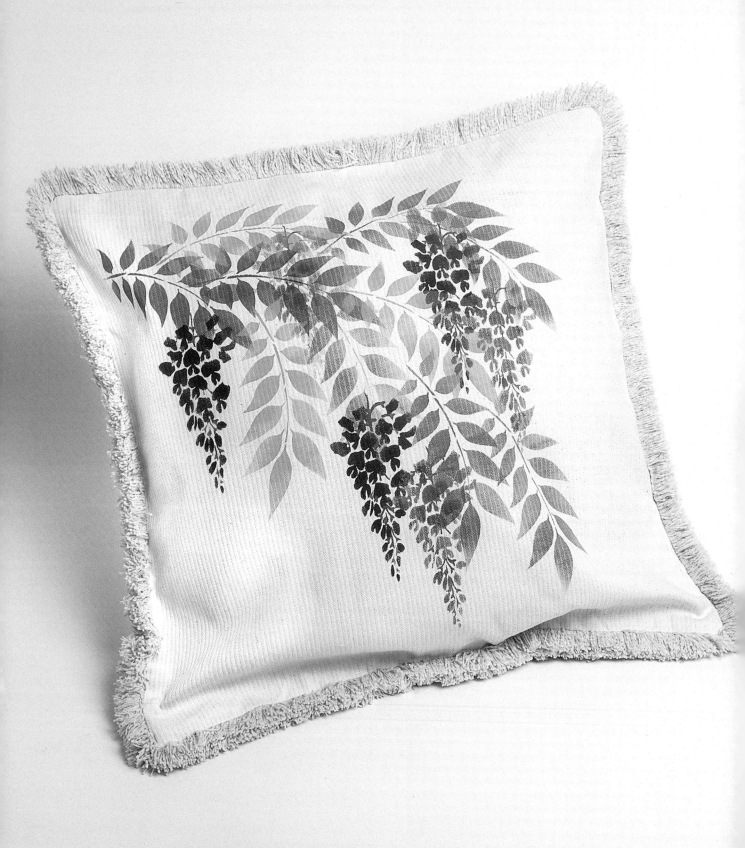

Whimsical Wisteria Pillows

Materials

2 yards (1.8 m) medium weight neutral twill or muslin

22-inch (55 cm) square cardboard or foamcore

1 can Elmer's spray adhesive

1 Buckingham "Wisteria" stencil

Buckingham roller paints:
- 1 bottle Spring Green
- 1 bottle Mountain Green
- 1 bottle Purple Iris

5 yards (4.5 m) 1½- to 2-inch (4 to 5 cm) neutral fringe

2 18-inch (45 cm) pillow forms

Tools

scissors

masking tape

palette paper or disposable plates

Buckingham stencil roller

Buckingham stencil roller refills

water container

paper towel

straight pins

neutral thread

sewing machine

Instructions

1. To remove sizing and preshrink the fabric, wash, dry and iron it without using fabric softener or dryer sheets. Cut four fabric pieces, each 21 inches (52.5 cm) square.

2 . In a well-ventilated area, spray the cardboard or foamcore with a light coating of the spray adhesive. Allow it to sit a few seconds, then apply one of the pieces of fabric, right side up, to the board. The adhesive will gently hold your fabric flat while you paint.

3. Read the instructions in the Buckingham stencil package carefully. Measure approximately 3 inches (7.5 cm) down and 2 inches (5 cm) in from the upper left corner of the fabric. Place the leaf stencil on a sweeping angle, heading towards the middle bottom of the fabric. Tape the stencil in place.

4. Squeeze a line of the Mountain Green paint onto your palette. Roll the stencil roller into the paint, covering the roller completely. Roll any excess paint off on paper towel. Gently and evenly roll over the stencil to create pattern. The leaves will automatically be shaded due to the nature of the paint application.

5. Remove the stencil and repeat the process, moving toward the middle and bottom of the fabric and creating the look of draping branches.

6. Replace the sponge roller with a fresh one, setting the dark green roller aside. Tape the stencil down again, overlapping some of the dark green areas, and stencil the lighter green leaves onto the fabric.

7. Once again, replace the roller with a fresh one. Tape the Wisteria stencil (flower portion) so the flowers are dropping from the leaves. Use the purple paint to fill in the flowers. You will probably need to stencil approximately six bunches of flowers.

8. After the flowers are relatively dry, place the stem overlay portion of the stencil on top of the flower portion, lining the stems up with the flowers. Stencil the stems with the darker green. Repeat this step for all bunches of flowers.

9. Follow steps 3 to 8 again to create a second pillow front. Allow all paint to dry thoroughly.

10. Sew the fringe to the inside edge of the painted sections of the pillows, clipping the corners. Sew the front and back of the pillow, rights sides together, leaving an opening of approximately 12 inches (30 cm). Turn the pillow right side out and insert the pillow form. Neatly sew the opening, either with the sewing machine or by hand.

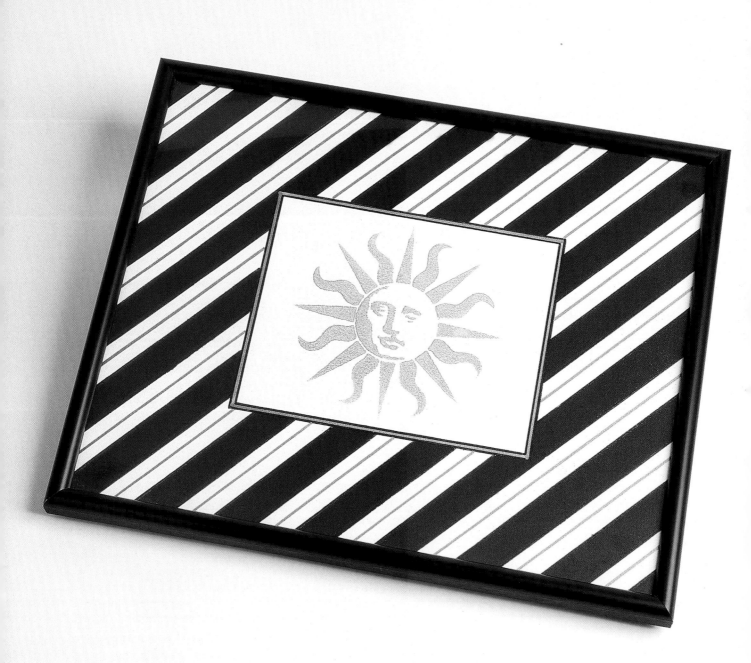

Easy Art Deco

Materials

1 16" x 20" (40 cm x 50 cm) canvas
 panel board
Ceramcoat acrylic paint:
 1 bottle Black
 1 bottle Kim Gold Gleams
1 wide-tip gold paint pen
1 Buckingham "Large Sunburst" stencil
1 16" x 20" (40 cm x 50 cm) black
 picture frame

Tools

pencil
yardstick
wide masking tape
X-acto knife
small foam paint brush
water container
paper towel
small foam roller

Instructions

1. On the 20-inch (50 cm) sides of the panel, make a pencil mark 4 inches (10 cm) from the edge. On the 16-inch (40 cm) sides of the panel, make a mark 5 inches (13 cm) from the edge.

2. Using the marks as a guideline, with a pencil and ruler draw a rectangle in the middle of the panel.

3. Place the board with one of the 20-inch (50 cm) sides facing you. Start at the upper left corner and begin applying pieces of tape diagonally across the panel. Leave 1$\frac{1}{2}$ inches (4 cm) between each piece of tape.

4. With the X-acto knife, carefully cut and remove the tape from the inside of the rectangle. Tape around the inside edge of the rectangle to avoid getting any paint in that area.

5. With the small foam brush, apply two coats of the black acrylic paint to the open areas of the stripes you have created. Let the paint dry completely after each coat.

6. Remove the tape. Draw a diagonal stripe with the gold paint pen $\frac{1}{4}$ inch (0.5 cm) from the upper edge of each black stripe ensuring that you don't draw gold lines through the middle rectangle. Let the ink dry.

7. Draw a slightly thicker gold line to outline the rectangle to create a border. Let it dry.

8. Center the stencil in the middle of the rectangle. Tape it in place.

9. Roll the small foam roller into the gold paint, covering the roller completely. Roll most of the paint off on a paper towel. Apply a thin coat of gold paint over the stencil using a light, even pressure on the roller.

10. Gently remove the stencil and wash immediately. Allow the painting to dry overnight.

11. Frame and hang your artwork on the wall.

Sue's Tip

What's the secret behind painting stripes and plaids? What makes stenciling and block printing so easy? Well, having all the right tools at your fingertips will put you on the road to success. Use light lead pencils to make your markings, make sure your ruler or yardstick is long enough to cover the full area you are marking off and always have masking tape in various widths on hand.

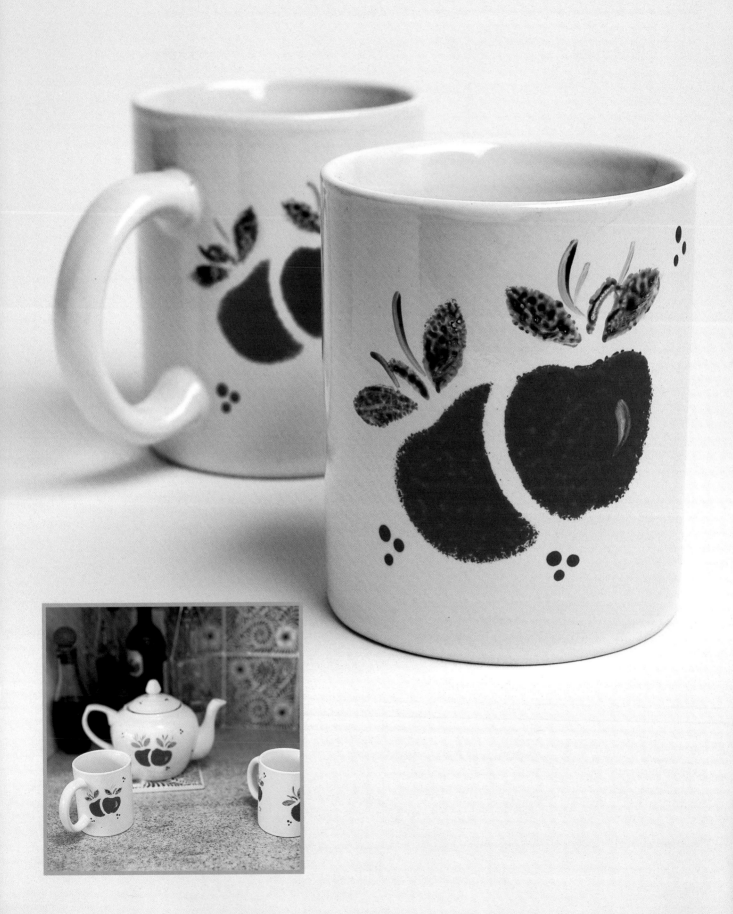

Hand-Painted Apple Mugs

Materials

4 plain white ceramic mugs
Pebeo 150 instruction booklet (issue No. 1)
Pebeo Porcelaine 150 paints:
 1 bottle red
 1 bottle green
 1 bottle yellow

Tools

rubbing alcohol
paper towel
scissors
narrow masking tape
small stencil spouncers
small round paint brush
water container

Instructions

1. Clean the mugs thoroughly with rubbing alcohol to remove any grease or dirt from the surface. Wash and dry the mugs thoroughly.

2. Cut the apple stencils from the instruction booklet. Plan your design and decide where you want your first apple to go. Tape the stencil firmly to the mug.

3. Start with the red area of the apple. Apply a very small amount of the red paint to the spouncer. With a light dabbing motion, spounce the paint onto the stencil.

Sue's Tip

Never dilute these paints with water. Water interferes with the adhesion of the paint. You can, however, purchase a special extender that will make the paint more translucent.

If you make a mistake as you are painting, simply use a cotton swab to remove any small smudges or wash it all off and start again.

4. Thoroughly wash the red from the spouncer and blot it dry. Apply a small amount of green and fill in the leaves of the apple. Allow each area to dry before moving on to the next. You can speed the drying process up by using a hair dryer. Once one area is dry, remove the stencil.

5. Repeat the process with the smaller apples until you are satisfied with the pattern on your mug. Let it dry.

6. Apply a small amount of the yellow paint to your small round paint brush. Put a small stroke of yellow on the right side of the apples to highlight. Add a little yellow to the leaves as well.

7. With the end of the brush, make small dot patterns in the open areas of the mug.

8. Repeat with the other three mugs. Allow the paint to dry for at least 24 hours.

9. Bake the mugs in a 325° F (165° C) oven for 30 minutes.

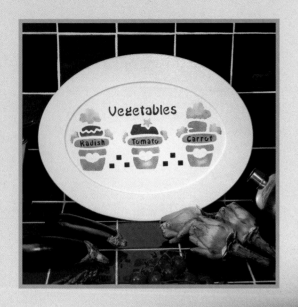

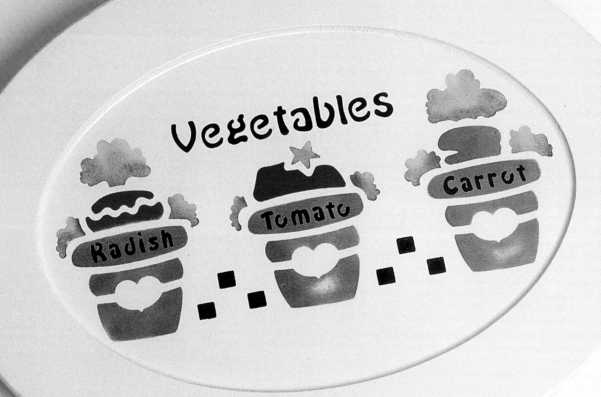

Veggie-Stenciled Tray

Materials

1 Walnut Hollow 12" x 16" (30 cm x 40 cm) oval basswood tray
1 small bottle Americana matte acrylic varnish
 Americana acrylic paint:
 1 bottle French Vanilla
1 Stencil Time "Country Garden Vegetables" stencil OR 1 garden vegetable stencil of your choice
DecoArt stencil paint:
 1 jar Avocado Green
 1 jar Cadmium Yellow
 1 jar Deep Burgundy
 1 jar Burnt Sienna
 1 jar Charcoal Gray

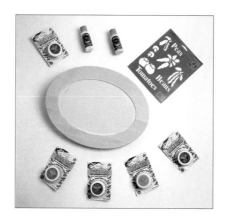

Tools

fine grit sandpaper
paper towel
medium foam paint brush
very small stencil brushes
water container
stencil tape

Instructions

1. Gently sand the tray to eliminate any rough edges. Wipe sand particles off with a damp paper towel.

2. With the medium foam brush, apply a coat of acrylic varnish to tray to seal the wood. Let it dry thoroughly.

3. Apply two or three base coats of ivory paint. Let the tray dry after each coat.

4. Center the stencil in the middle of the tray and tape it in place. Begin painting the top leafy area of the veggies with the green. (See Note for stenciling advice.) Using the picture on the stencil as a guide, fill in all the green areas of the leaves.

5. Using the same brush, blot off as much of the green paint as possible on the paper towel and tip the brush with the yellow. Blot and begin blending a little yellow into the green, just enough to highlight the leaves.

6. Stencil all the leafy areas with yellow, the tomato with burgundy, the carrot and pots with Burnt Sienna, the squares and writing with gray, and the radish with burgundy. Allow the paint to dry thoroughly, at least overnight.

7. Apply two or three coats of acrylic varnish. Allow the varnish to dry after each coat.

Note: When loading your stencil brush with paint, blot most of the paint on the paper towel before you begin to apply it to your project. Too much paint will smear under the stencil and ruin your work. Apply the paint from the outer edges of the stencil image, pulling your color into the middle. Do not wash your brushes as you change colors.

Sue's Tip

Remember when you are working with stencil cremes, they take much longer to dry than acrylics. Ensure your project is completely dry to the touch before applying the varnish.

I have used a specific stencil for this project. However, if you are unable to find this stencil, substitute another image. There are many different stencils on the market and they change all the time. If you stay with the "veggie" theme, you will be able to incorporate the same paint colors.

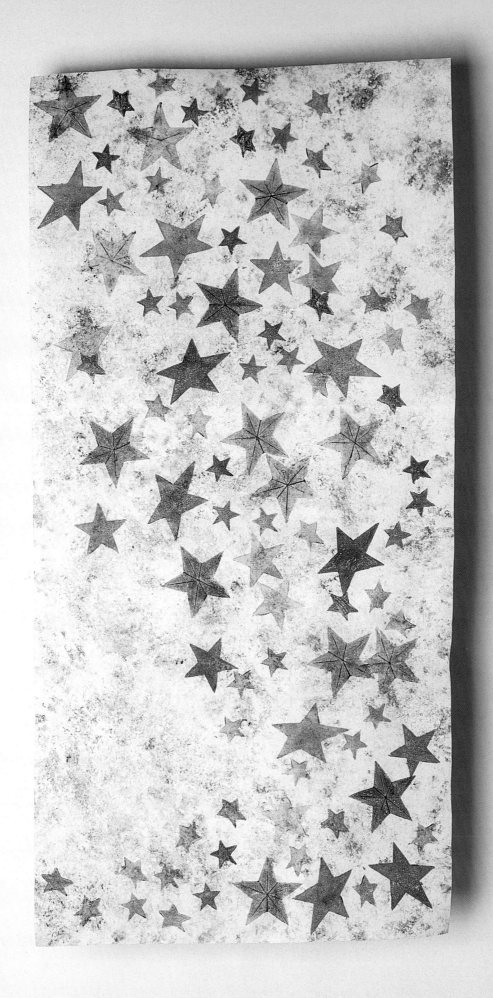

Bath-Time Decor For Kids

Materials

1 piece pre-gessoed 30" x 15" (75 cm x 38 cm) canvas
1 small bottle Liquitex white gesso
1 package stars Plaid Decorator Blocks
Plaid Decorator glazes:
 1 bottle Plate Blue
 1 bottle White
 1 bottle Geranium Red
1 can Folkart Clearcote acrylic sealer spray

Tools

small foam roller
water container
palette paper or disposable plates
large sea sponges
paper towel
small flat paint brushes

Instructions

1. With the small foam roller, roll the gesso onto the canvas, keeping your strokes even. (Although this canvas is pre-gessoed, a second coat is needed to give the canvas extra strength and durability.) Clean the roller immediately. Allow the gesso to dry thoroughly. If the canvas starts to curl while it is drying, flatten it out by gently rolling it in the opposite direction of the curl.

2. Squeeze a line of the dark blue glaze onto your palette. Drizzle a line of white glaze on top of the blue glazes. Do not mix them.

3. Dampen both sponges. Dip the first sponge into the blue and white glaze. Dab the excess off on a paper towel. Hold the sponge with the glaze in one hand and the clean damp sponge in the other hand. Begin applying the color onto the canvas. With the clean damp sponge, go back over the glaze immediately and dab again. The damp sponge adds a little more water to the canvas and allows the colors to bleed, giving you a cloud effect. Continue this process until you have the desired look. Allow the canvas to dry completely, once again straightening any curls.

4. Following package instructions, print blue and red stars using the glazes on the canvas. Begin at the lower left corner of the mat and work your way up, widening your pattern as you progress. Use second and third prints of the stars to create dimension and softness forming a starburst design. (It's a good idea to test your pattern first on a piece of paper before applying it to the canvas.) When you have the amount of design you want, allow the glaze to dry thoroughly.

5. In a well-ventilated area, spray the mat with two or three coats of the acrylic sealer. Allow drying time after each coat.

Sue's Tip

Consider putting a non-skid pad under the floor mat. These pads are available at most hardware stores and will prevent the cloth from slipping under foot. Alternatively, you can brush on a light coat of latex rubber backing, again available at most hardware stores. Keep those little feet on the floor and not in the air!

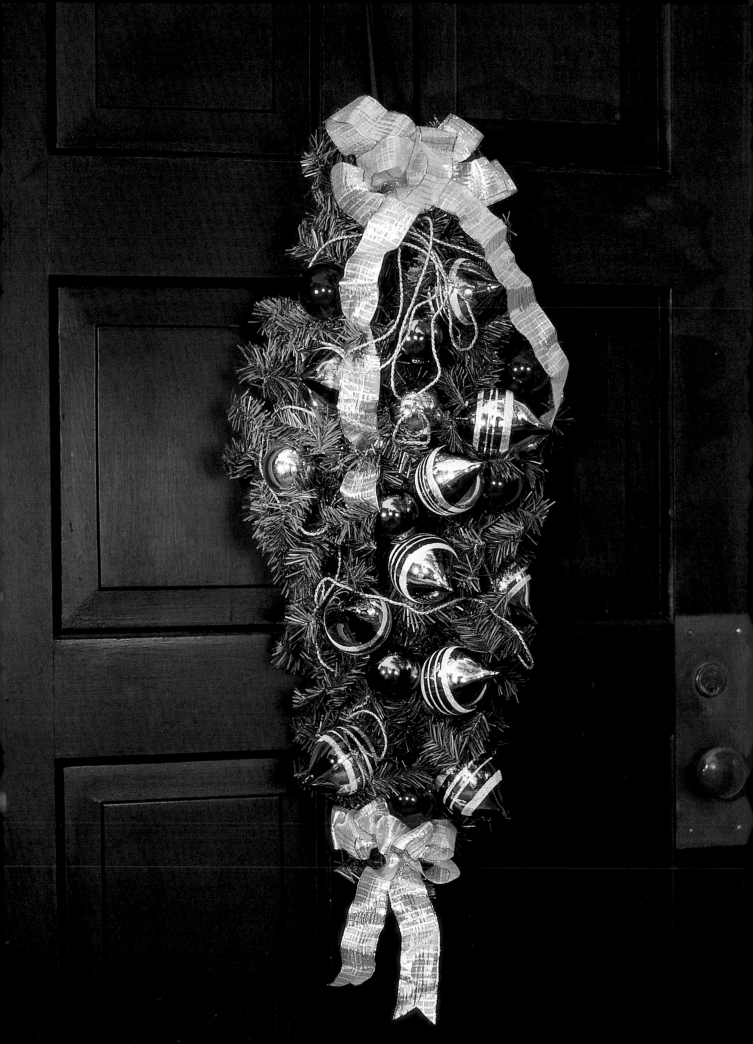

It's
Christmas

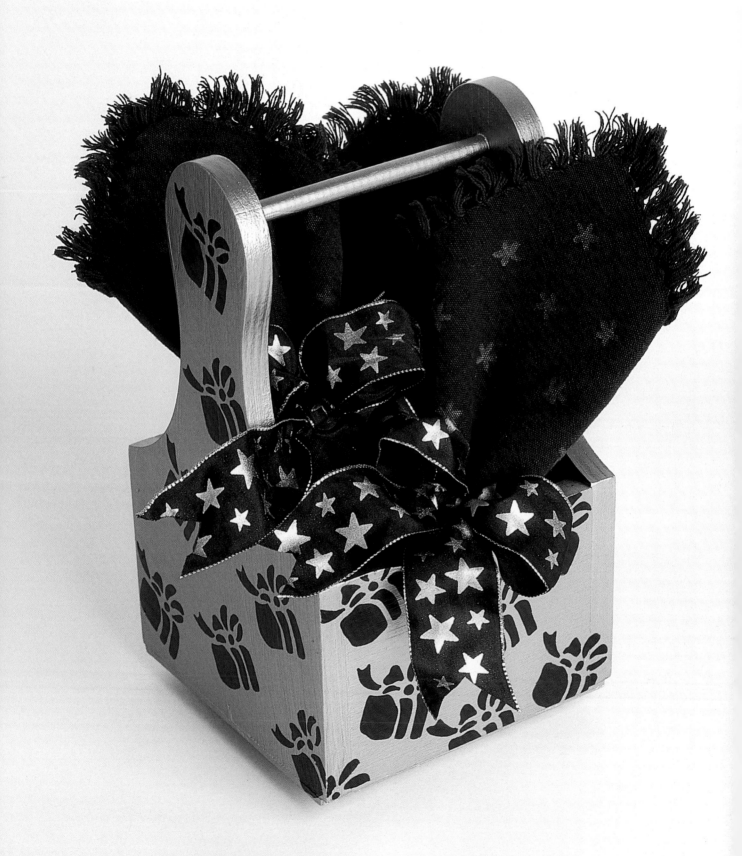

Christmas Napkin Caddy

Materials

1 Walnut Hollow wooden caddy with handle
1 can Americana matte acrylic sealer/
 finisher spray
1 can Design Master Antique Gold spray
 paint
1 Plaid Simply Stencils for Christmas
1 Staedtler black pigment marker
4 black cotton napkins
1 Rubber Stampede small star stamp
1 gold pigment stamp pad
2 yards (1.8 m) 1$\frac{1}{2}$-inch (4 cm) Offray
 black ribbon with gold stars

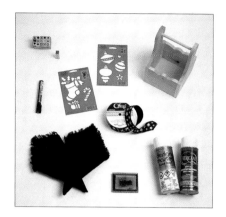

Tools

fine grit sandpaper
paper towel
water container
stencil tape
ball-point pen
scissors

Instructions

1. Sand the box well. Wipe any dust particles off with a damp paper towel.

2. In a well-ventilated area, spray the entire caddy with one coat of the sealer/finisher. Let it dry.

3. Spray the entire caddy, inside and out, with two or three coats of the gold spray paint. Let it dry after each coat.

Sue's Tip

You can create this design using many different techniques. Try using the stencil with acrylic paint or stencil paints. You can also vary the stencils and colored markers for a more traditional look.

4. Decide on the design you wish to use. Place the stencil on one side of the caddy and tape it in place. With the ball-point pen, trace the design onto the caddy. Repeat on the other three sides.

5. Using the pigment marker, trace over the pen lines and fill in the design. The marker is permanent and will take only a few seconds to dry. Let it dry completely.

6. Apply two or three coats of sealer/finisher to the entire box, allowing it to dry after each coat.

7. Stamp small stars onto all four napkins.

8. Tie each napkin with $\frac{1}{2}$ yard (45 cm) of the star ribbon and insert the napkins into the caddy.

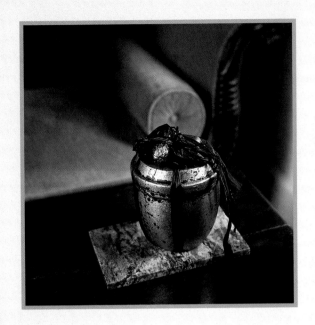

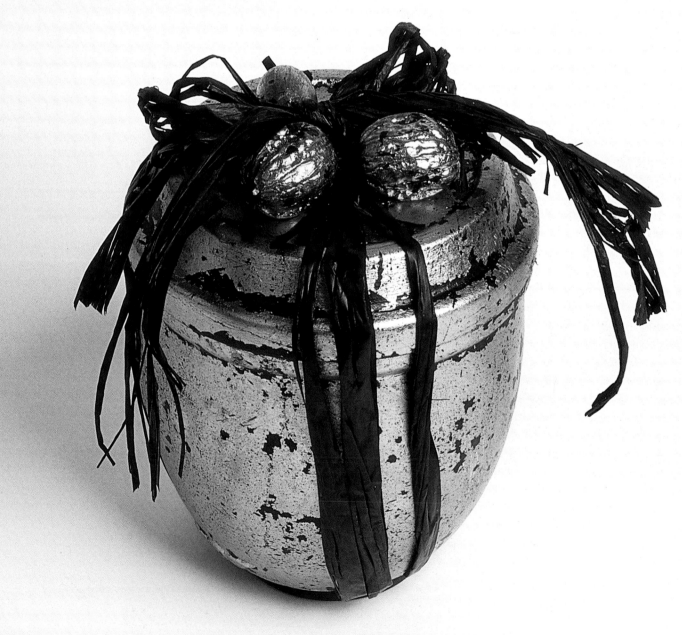

Copper Nut Jar

Materials

1 medium-sized clay pot (shown painted)
1 clay pot saucer
Ceramcoat acrylic paint:
 1 bottle Black
1 bottle Houston Art Leaf Adhesive
1 package Houston Art Composition Copper
 Leaf
1 can Americana matte acrylic sealer/
 finisher spray
1 large bag unshelled mixed nuts
1 package black or natural raffia

Tools

medium foam paint brush
water container
paper towel
sea sponge
small stiff paint brush
old toothbrush
hand drill with small bit
scissors

Instructions

1. With the medium foam brush, apply two or three coats of black acrylic paint to the entire clay pot and the saucer. Let them dry after each coat.

2. With the sea sponge, dab the leaf adhesive all over the outside of the pot and saucer. Do not completely cover them with the adhesive. Let the adhesive dry for approximately two hours.

3. Apply the copper leaf to the outside of the pot one sheet at a time. Place the sheet over a small area of the pot. With the small stiff paint brush, pat and brush the leaf into place. You will notice that the leaf will fall away from the areas where the adhesive has not been applied and the black paint will show through. This is the desired look. Continue this process until the entire pot and saucer are covered with the leaf. If you wish a heavier application, apply a light coat of the adhesive in the open areas. Allow it to dry and continue to apply the leaf in the same manner.

Sue's Tip

When clay pots go on sale in your local garden shop, buy up a few and you can incorporate them into many projects throughout the year.

4. Dilute a small amount of the black paint with water to achieve an inky consistency. Dip the toothbrush into the inky paint and run your nail down the brush while holding it over the pot and lid. The inky paint will spray lightly onto the pot. Continue this process until you have the desired amount of splattered black paint. Let all the paint dry.

5. Apply a light spray of the sealer/finisher over the entire pot and saucer.

6. Drill a hole down the center of three large nuts.

7. Paint and copper leaf the nuts in the same manner as the pot, spraying them with the sealer/finisher and allowing them to dry.

8. Fill the pot with the remaining nuts and cover them with the saucer lid.

9. Wrap several strands of black raffia around the pot to hold the lid on. Draw the raffia back up to the top of the pot and tie a bow, leaving tails. Slip one strand of raffia from the tails through the hole in one of the nuts. Tie a knot at the end. Repeat this with the other two nuts, allowing them to dangle over the edge of the pot.

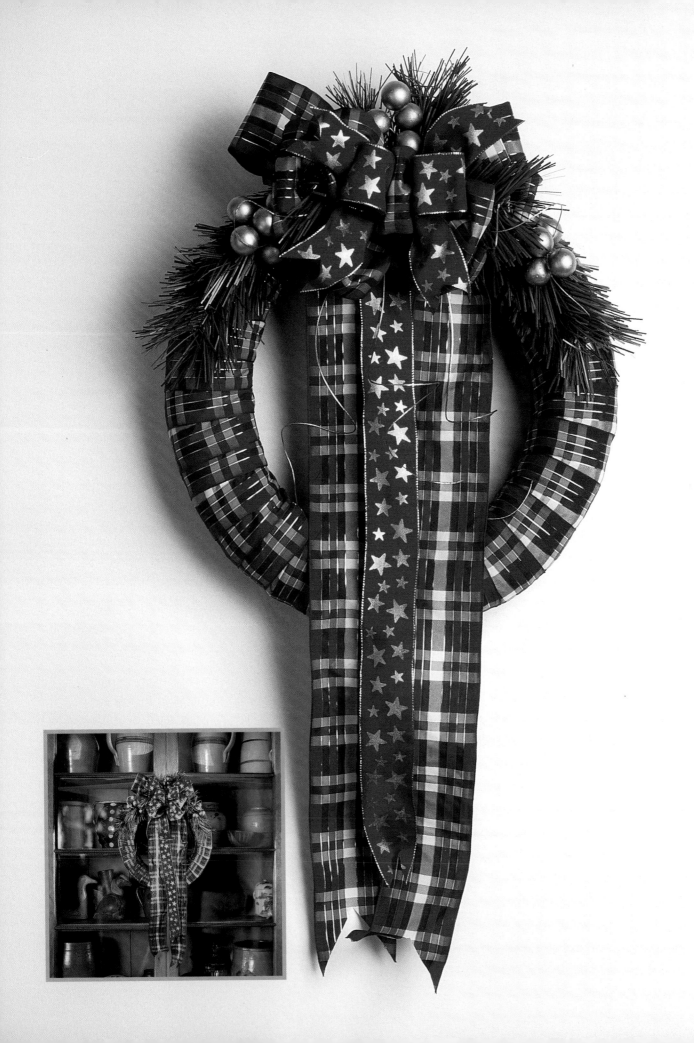

Shimmering Christmas Wreath

Materials

1 12-inch (30 cm) straw wreath

10 yards (9 m) 3-inch (7.5 cm) Offray
 wired Christmas ribbon

2 yards (1.8 m) 1$\frac{1}{2}$-inch (4 cm) Offray
 wired Christmas ribbon

1 PVC greenery pick

1 spray large gold berries

1 package Sheldricks gold ting ting

1 paddle 24- to 26-gauge floral wire

Tools

wire cutters

glue gun with glue sticks

scissors

Instructions

1. Glue one end of the 3-inch (7.5 cm) ribbon to the top of the wreath. Wrap and overlap the ribbon around the wreath until the entire wreath is covered. Glue the ribbon down where you finish.

2. With the remainder of the 3-inch (7.5 cm) ribbon, make a multi-loop bow, leaving long tails. Wire the bow firmly to the top of the wreath. Glue the bow to the wreath after you have wired it.

3. With the 1$\frac{1}{2}$-inch (4 cm) ribbon, make two small loops. Wire the center of each loop with a small amount of wire, leaving ribbon tails approximately 3 inches (7.5 cm) long.

4. Insert and glue one small loop into the left area of the bow and the second small loop into the right area of the bow.

5. With the 1$\frac{1}{2}$-inch (4 cm) ribbon, make a long tail and attach it under the multi-loop bow to drape down the front of the wreath along with the tails from the larger bow.

6. With wire cutters, cut the PVC greenery pick apart. Glue small pieces of greenery in and around the large bow.

7. With wire cutters, cut the berries apart. Group small amounts of berries and glue them throughout the bow.

8. Insert and glue small pieces of the ting ting into the bow.

Sue's Tip

We never seem to tire of the beautiful colors of Christmas, especially those fabulous ribbons that are embellished with gold. You can achieve a very delicate look by simply adding little touches of gold. For example, place small gold leaves at the base of candles and candle holders. Mix gold with cranberry and hunter green for dynamic appeal or with soft ivory for that Victorian flavor.

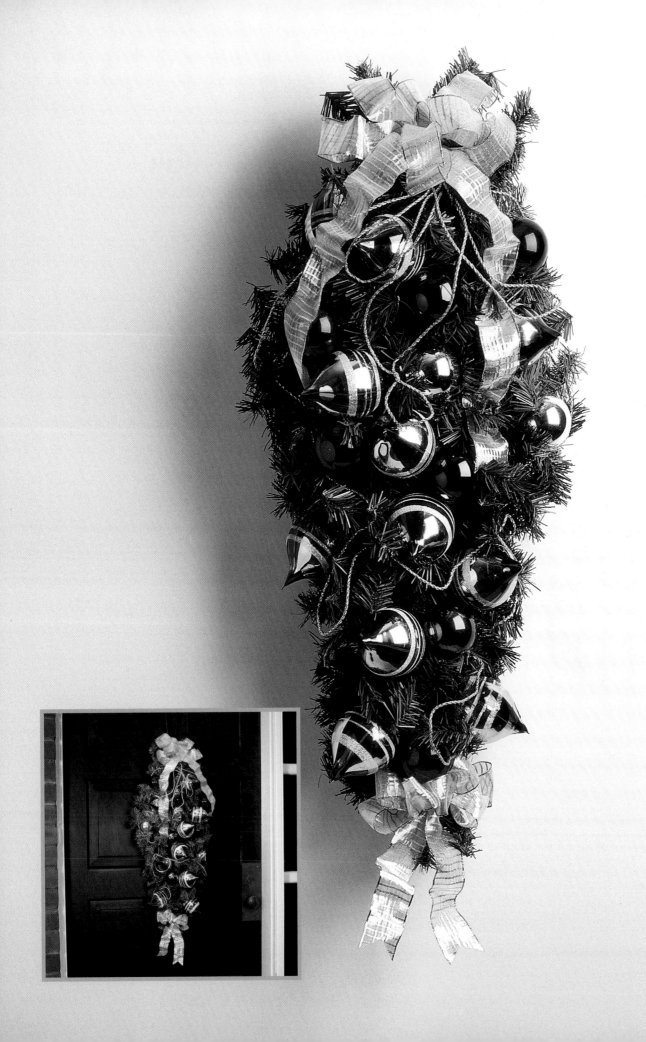

Christmas Ball Drop

Materials

1 9-foot (2.75 m) PVC greenery garland
1 paddle 24- to-26 gauge floral wire
4 boxes Christmas balls in various sizes and
 colors
5 yards (4.5 m) 1$\frac{1}{2}$-inch (4 cm) Offray
 wired Christmas ribbon
3 yards (2.75m) Domcord Belding narrow
 gold cording
sturdy ribbon or string

Tools

wire cutters
glue gun with glue sticks
scissors

Instructions

1. Fold the garland in half and in half again. Shape it until it takes on a rounded appearance.

2. Wire the garland together at the top and bottom. This is your drop.

Sue's Tip

This is a really easy and inexpensive way to decorate for the holiday season. Consider giving this as a gift! Vary the colors of the balls to create whatever effect you wish. Adding a little cording or ribbon throughout the drop in between the Christmas balls adds a different texture to your design.

3. Glue the Christmas balls throughout the drop, alternating the colors and textures of the balls as you go.

4. With three yards (2.75 m) of the ribbon, make a multi-loop bow and attach it to the top of the drop.

5. With the rest of the ribbon, make a smaller multi-loop bow and wire it to the bottom of the drop.

6. With the gold cording, make a loopy bow and attach it under the top multi-loop bow. Allow it to drape throughout the garland.

7. Tie a small piece of ribbon or string to the wire at the top of the drop as a hanger.

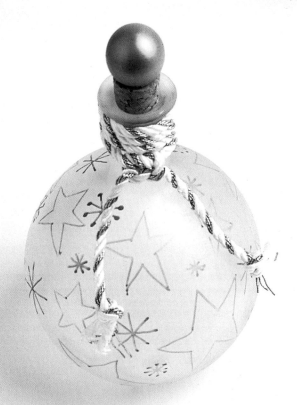

Winter Frost Decorator Bottles

Materials

2 or 3 decorator bottles in different shapes
 and sizes (with corks)
1 jar Armour Etch etching cream
1 narrow gold paint pen
Ceramcoat acrylic paint:
 1 bottle Kim Gold Gleams
2 or 3 small wooden balls
2 yards (1.8 m) Domcord Belding gold
 cording

Tools

rubber gloves
medium foam paint brushes
water container
paper towel
small foam paint brushes
glue gun with glue sticks
scissors

Instructions

1. Remove the corks from the bottles. Wearing rubber gloves, apply a layer of the etching cream to a small area of one of the bottles using the medium foam brush. Leave the etching cream on the bottle for approximately one minute, following the manufacturer's instructions, then rinse. Continue this process until you have etched the entire surface of the bottle to create a frosted look.

2. With the gold paint pen, make stars, flowers and various shapes on the outside surface of the bottle. Allow the paint to dry. Repeat this process with the other bottles.

3. With the small foam paint brush, apply two or three coats of gold paint to the wooden balls, letting the paint dry thoroughly after each coat.

4. Glue a ball to the top of each bottle cork. The ball acts as a handle.

5. Wind the gold cording around the neck of each bottle several times and tie it off, leaving draping tails.

Sue's Tip

Find bottles with different textures, colors and shapes. You can do any number of things with them: group them in uneven numbers, adding a floral arrangement and various shapes and sizes of candles. Fill the bottles with bath oil. Use them as beautiful decorations for Christmas or all year round.

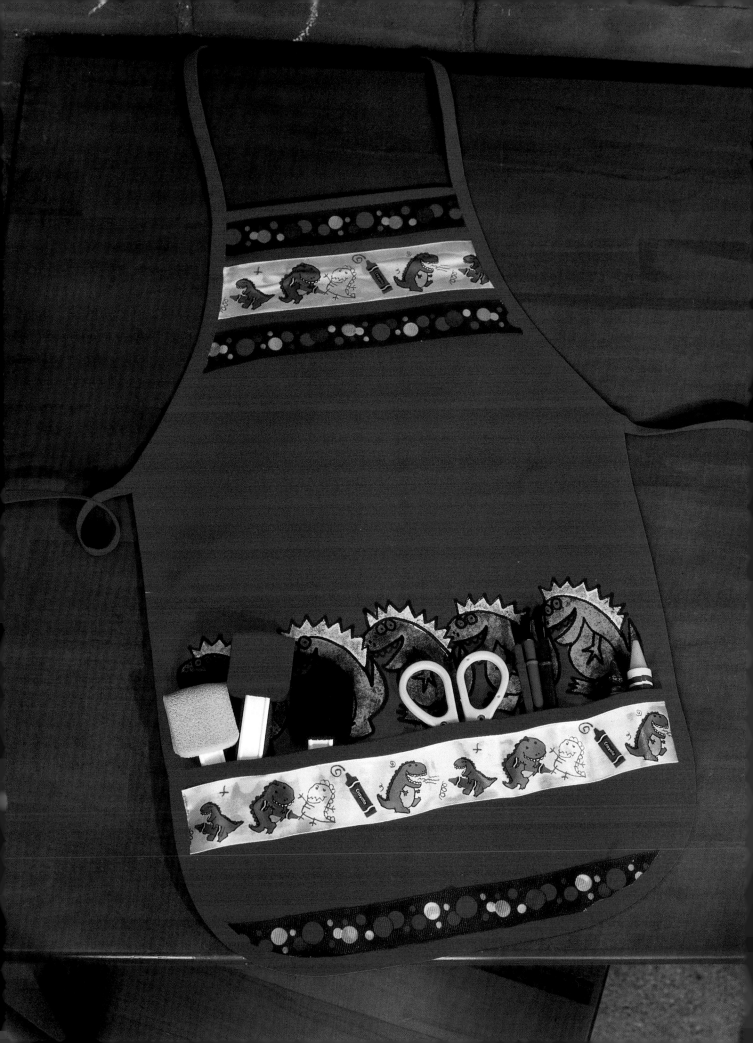

Kid's Day

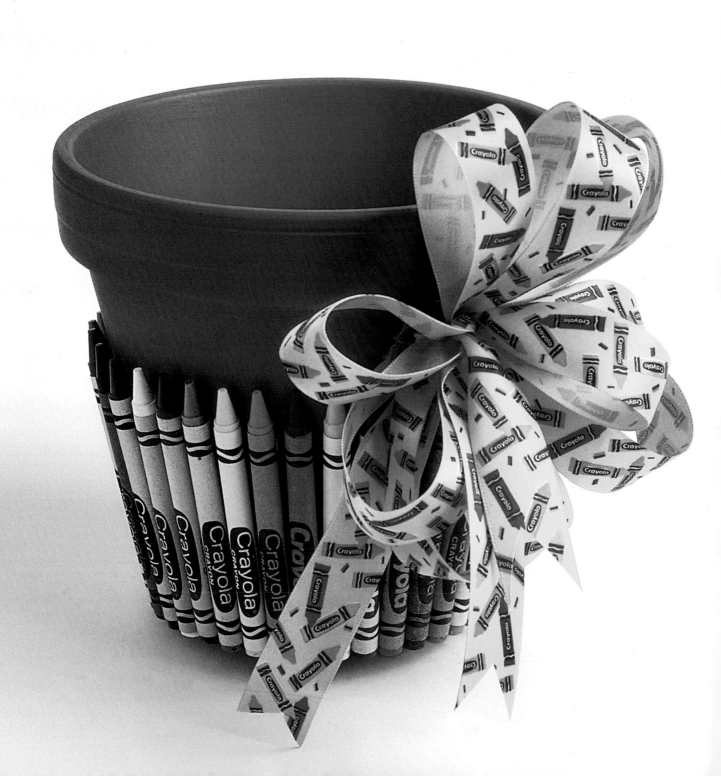

Kid's Crayon Caddy

Materials

1 6-inch (15 cm) clay pot
Anita's acrylic paint:
 1 bottle Medium Blue
64 Crayola crayons
3 yards (2.75 m) 1½ inch (4 cm) Offray
 Crayola ribbon

Tools

small foam paint brush
water container
paper towel
low-temperature glue gun with glue sticks OR
 Aleene's Designer Tacky Glue
scissors

Instructions

1. Paint the pot, inside and out, with the blue acrylic paint. Allow the paint to dry thoroughly. Apply a second and third coat if necessary. Let the paint dry after each coat.

2. Glue the first crayon to the outside of the clay pot with the bottom of the crayon facing the bottom of the pot and the pointed end of the crayon pointing up. Continue to glue more crayons. The bottom ends of the crayons should touch together. Due to the shape of the pot, the pointed ends will fan out as you work your way around. Continue until you return to your starting point.

3. With the Crayola ribbon, make a multi-loop bow. Glue it on one side of the pot, just below the rim.

4. Glue the tails of the bow loosely to the rim of the pot.

Sue's Tip

Going to a birthday party? This little caddy makes a great gift. Fill it full of crayons and surprise your friends with a handmade gift.

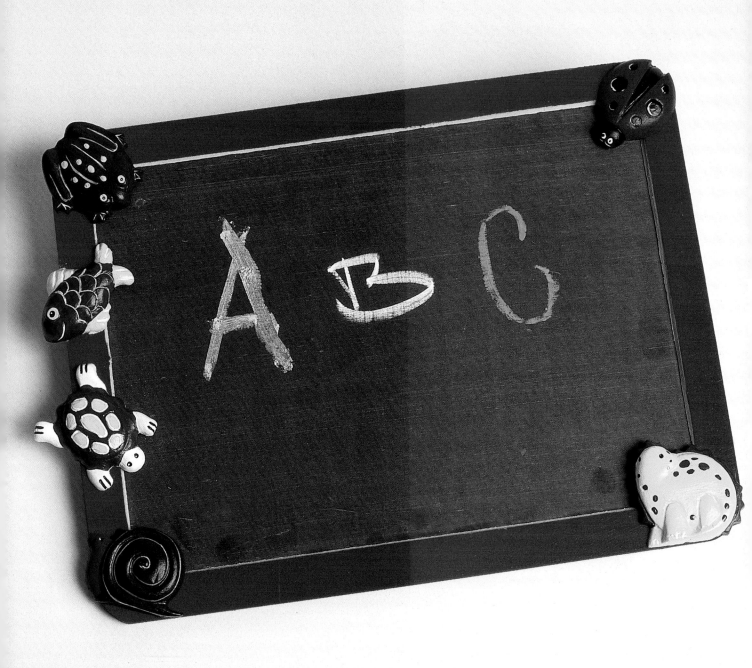

Bugs 'n' Critters Blackboard

Materials

1 Plaid Faster Plaster Beginner Kit "Bugs and Critters" (No. 67105)
1 17" x 10" (42.5 cm x 25 cm) blackboard
1 Plaid Primary Paint set with Brush
1 small bottle matte Mod Podge

Tools

water container
paper towel
Aleene's Designer Tacky Glue

Instructions

1. Following the instructions on the Faster Plaster package, make one of each bug and critter. (You will not require the full bag of plaster. Prepare only the amount you require, approximately half the bag, and save the rest for another project. If you need a little more, mix it as you need it. Once you have mixed the plaster, you have to use it immediately.) Allow your bugs and critters to dry completely. Pop the plaster pieces from the mold and microwave as directed.

Sue's Tip

You can make another set of bugs and critters to decorate other items in your room. Paint the second set with different color combinations. To make a bug jar, glue bugs and critters onto the sides of an ordinary household jar.

2. With the paint set, paint each piece, making up your own designs and color combinations. Set the bugs and critters aside to dry.

3. Paint the wooden frame of the blackboard red. Allow it to dry thoroughly.

4. When everything is dry, apply a thin coat of podge to the frame of the blackboard and to each bug and critter. Do not apply podge to the backs of the bugs and critters. Let the podge dry.

5. Apply a thin layer of Tacky Glue to the back of each plaster piece and glue them onto the frame of the blackboard. Allow the glue to dry overnight.

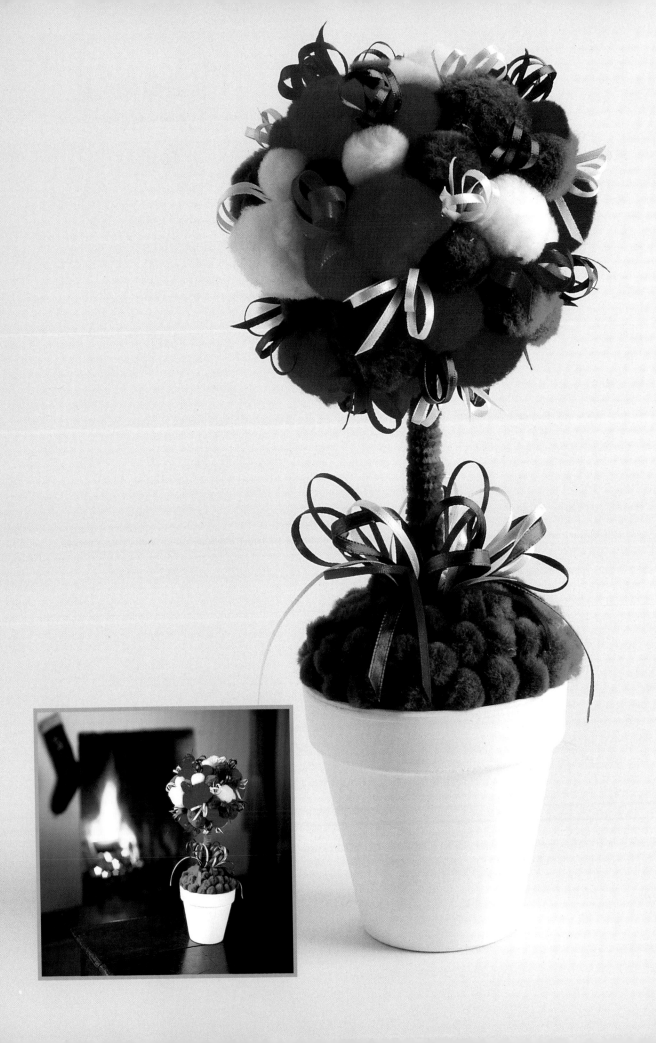

Pom Pom Topiary Tree

Materials

1 4-inch (10 cm) clay pot
Ceramcoat acrylic paint:
 1 bottle white
1 small bottle matte Mod Podge
2 4-inch (10 cm) Styrofoam balls
1 large bag assorted Christmas pom poms
1 new lead pencil
1 package green chenille stems
Offray Spool o' Ribbon:
 1 roll white
 1 roll green
 1 roll red

Tools

small foam paint brushes
water container
paper towel
low temperature glue gun with glue sticks OR
 Aleene's Designer Tacky Glue
scissors

Instructions

1. Paint the clay pot with two or three coats of white acrylic paint. Allow drying time after each coat.

2. Apply a layer of the podge to the outside of the pot and allow it to dry.

3. Push one of the Styrofoam balls snugly into the pot. Glue a layer of small green pom poms over the top of the ball, covering it completely.

4. Wrap the pencil with the green chenille stems. Leave 1 inch (2.5 cm) at each end of the pencil uncovered.

5. Glue poms poms in various sizes and colors all over the second Styrofoam ball, covering it completely.

6. Make several small loopy bows from the different colored ribbon and glue them into the second Styrofoam ball between the pom poms. Make the bows large enough that they spray out from between the pom poms.

7. Insert and glue one end of the pencil into the middle of the pot. Insert and glue the pom pom ball on top of the other end of the pencil.

8. Make two large loopy bows with all three colors of the ribbon and glue one bow into each side of the pot beside the stem.

Sue's Tip

You can make this topiary tree for any season. For spring, use pastel colors, or for Halloween, use black, orange and yellow. You can also make this project any size you want. Just increase the size of the pot and the Styrofoam balls. Be creative and paint a special design on the pot.

Tropical Rainstick

Materials

1 piece colored poster board
3 to 4 sheets colored construction paper
1/2 cup (125 mL) uncooked rice
1 package Crayola glitter glue
1 package Crayola markers
1 package mixed colored feathers

Tools

scissors
low temperature glue gun with glue sticks OR
 Aleene's Designer Tacky Glue
wide masking tape

Instructions

1. Cut a piece of poster board 7" x 14" (18 cm x 35 cm). Cut two pieces of poster board 2" x 14" (5 cm x 35 cm).

2. Cut two pieces of construction paper in colors of your choice 4" x 6" (10 cm x 15 cm).

3. Roll the 7" x 14" (18 cm x 35 cm) piece of poster board into a long cylinder, overlapping the edges by approximately 1 inch (2.5 cm). Glue the edges together. Hold the cylinder in place until the glue is dry.

4. Glue the two 2-inch (5 cm) strips of poster board together with a fine line of glue down the middle of the pieces. Allow the glue to dry. This is the core of the rainstick.

5. With the scissors, make slit cuts along the edges of the core, making sure you do not cut through the middle. These slits should be approximately 1/2 inch (1.25 cm) in length and approximately 1/2 inch (1.25 cm) apart. Do the same on both sides of the core.

6. Separate the slit pieces by gently folding one piece one way and the other piece the other way.

7. Insert the core into the middle of the rainstick, rotating it to form a spiral.

8. Cover one end of the rainstick completely with the masking tape.

9. Pour 1/2 cup (125 mL) uncooked rice into the open end of the rainstick. Tape up the remaining open end.

10. Glue one 4" x 6" (10 cm x 15 cm) piece of construction paper around each end of the rainstick. Make cuts to create a fringe.

11. Decorate the rainstick with pieces of colored construction paper, glitter glue and markers.

12. Glue three or four colored feathers to each end of the rainstick.

Sue's Tip

Regular white glue works really well on most projects. However, there are also great tacky glues on the market now that dry very quickly and put an end to frustration. Eventually, the glue gun comes into play and makes everything extra easy.

 It is never too early to encourage young crafters!

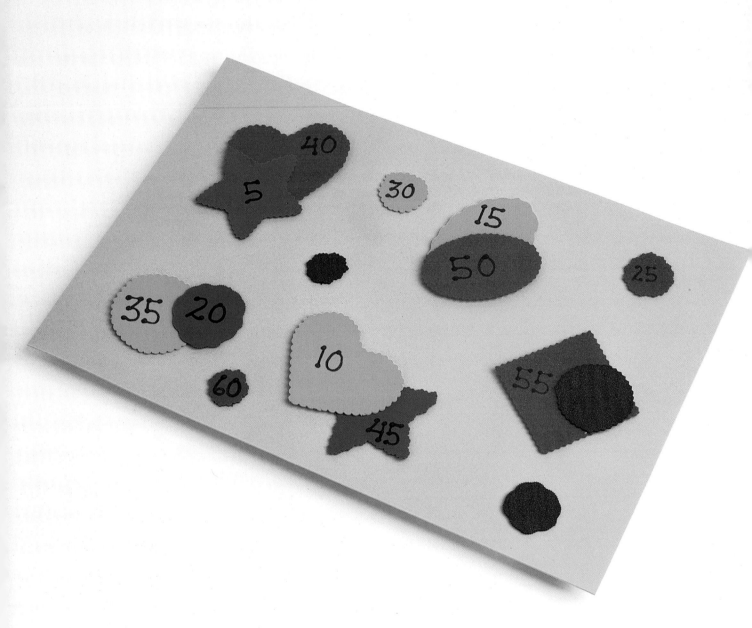

Friendship Game

Materials

1 Fiskars Basic Shapes Decorative Stencil
Westrim Fun Foam:

- 1 sheet yellow
- 1 sheet red
- 1 sheet blue
- 1 sheet black
- 1 sheet green
- 1 sheet white
- 1 sheet orange

5 large and 10 small buttons
1 black felt-tip marker

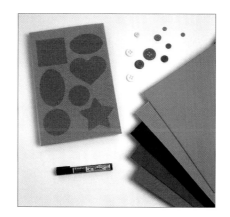

Tools

pencil
Fiskars Paper Edgers
scissors
Aleene's Designer Tacky Glue

Instructions

1. Use the Decorative Stencil to trace several shapes on pieces of colored Fun Foam. Cut the shapes out using the Paper Edgers. Save one full sheet of Fun Foam to act as the board for the game. Orange works well.

2. Glue your shapes onto the orange fun foam, spacing them approximately 4 inches (10 cm) apart. For fun, you may want to glue one smaller shape onto a larger shape. Allow the glue to dry.

3. Mark each Fun Foam shape with a number using the black marker. This number represents the points you score if your button lands on this shape.

4. Now comes the fun part – playing the game! Press down on a small button with the large button, making the small button pop up and land on the board. If the button lands on a shape, give the player the number of points written on the shape. Decide how many points wins the game, and continue until a player reaches the winning number.

Sue's Tip

This game is super to take on vacation. The kids have a great time making the game, and just as much fun playing it. For traveling, adhere the game board to a piece of wood using glue or spray adhesive. This technique also helps to preserve the life of the game.

Clay Pot Piggy Bank

Materials

1 4-inch (10 cm) clay pot
Anita's acrylic paint:
 1 bottle Baby Pink
4 1-inch (2.5 cm) wooden balls
Westrim Fun Foam:
 1 sheet pink
1 piece 1-inch (2.5 cm) thick Styrofoam
1 pink chenille stem
2 large flat pink buttons
1 package 1¼-inch (35 mm) wiggle eyes

Tools

small foam paint brush
water container
paper towel
scissors
X-acto knife
low-temperature glue gun with glue sticks OR
 Aleene's Designer Tacky Glue

Instructions

1. Paint the entire pot with two or three coats of pink acrylic paint. Allow drying time after each coat.

2. Paint the four wooden balls in the same manner. Allow everything to dry thoroughly.

3. While the pot and balls are drying, cut two pig's ears from the pink Fun Foam with the scissors. (You can draw the ears first if you like.)

4. Have an adult do this step. Trace the top of the pot onto the Styrofoam. With the X-acto knife, cut the Styrofoam to fit snugly inside the top of the pot.

5. Paint the piece of Styrofoam pink. Let it dry.

6. Poke one end of the chenille stem through the middle of the Styrofoam piece going from front to back.

7. On the back of the Styrofoam piece, push one end of the chenille stem through the hole in one of the buttons. Tie a knot in the chenille stem to hold it in place. This will form your handle and the pig's tail.

8. On the front side of the Styrofoam piece, curl the chenille stem around your finger to form the pig's tail. Trim if necessary.

9. Glue the pig's eyes to the bottom of the pot, placing them so they touch and pop up over the rim of the bottom of the pot.

10. Glue the second button just below the eyes to create the nose. Make sure the two holes of the button are side by side.

11. Glue the ears just slightly behind the eyes so they stick up.

12. Glue the wooden balls onto the underside of the pot, spacing them to make the legs. Make sure the pot will sit properly.

13. Place the Styrofoam into the end of the pot to create the stopper for the piggy bank.

Sue's Tip

You can have a lot of fun with this idea. Why not make a cow? Paint your clay pot white and make large black spots to resemble the cow's markings. Change the face accordingly and you have another look altogether.

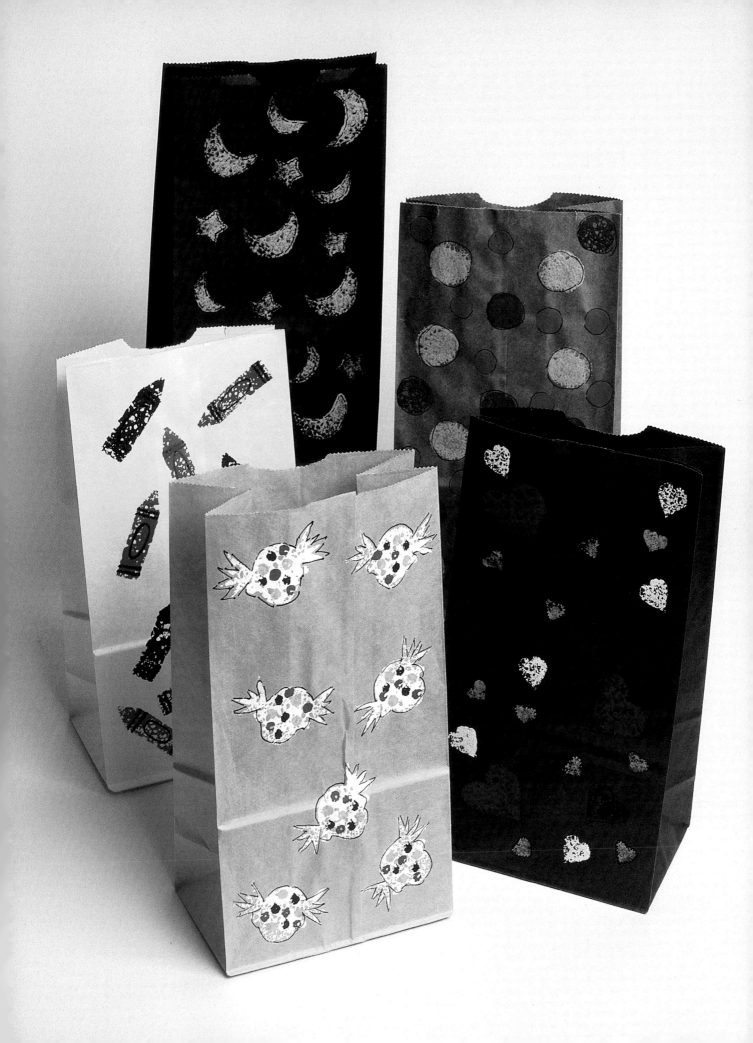

Spruced-Up Lunch Bags

Materials

shapes from magazines or coloring books
2 or 3 sheets plain paper
1 package Miracle Sponge compressed
 sponge
various colored paper bags
Anita's acrylic paints:
 1 bottle Raspberry
 1 bottle Buttercup
 1 bottle Navy Blue
 1 bottle White
 1 bottle Kelly Green
1 permanent black marker

Tools

pencil
scissors
water container
paper towel

Instructions

1. Find some really fun shapes in magazines or coloring books. Trace the shapes onto another piece of paper. Cut out your designs.

2. Trace the shapes onto the Miracle Sponge. Cut them out.

3. Drop the sponge shapes into water and watch them expand.

Sue's Tip

This is a great weekend project. Let everyone make a set of personal lunch bags, and the week ahead will be just a little brighter for the whole family. Kids, how about making a lunch bag or two for Mom and Dad?

4. Squeeze all the excess water out of the shapes. Dip the various sponges into the acrylic paints and have fun sponging wonderful designs on the paper bags. Try painting different colored hearts all over the bag. Another idea is using a large round shape for a baseball. Paint the baseball in white. When the paint is dry, draw the seam lines on the ball with the marker. How about a star-and-moon design?

5. When the paint dries, go around the shapes with the marker, adding dimension. Write funny sayings and have fun.

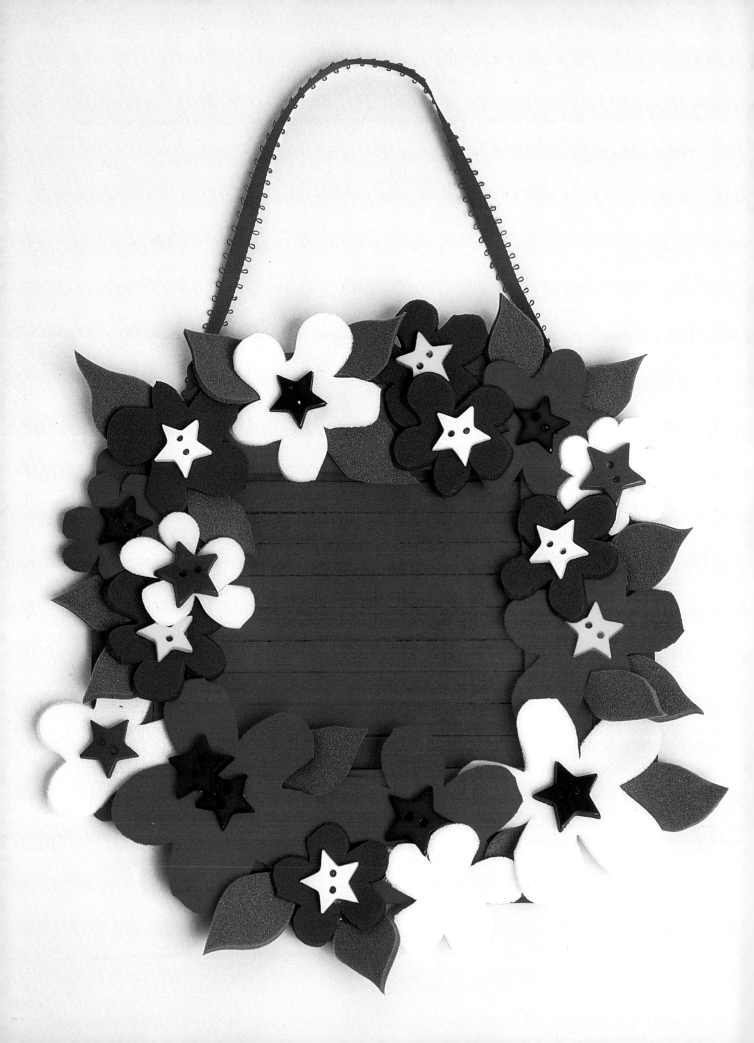

Colorful Button Picture Frame

Materials

1 box craft sticks
Aleene's acrylic paint:
 1 bottle Holiday red
Westrim Fun Foam:
 1 sheet red
 1 sheet yellow
 1 sheet blue
 1 sheet green
2 packages brightly colored buttons
Offray Spool o' Ribbon:
 1 roll red

Tools

Aleene's Designer Tacky Glue
small foam paint brush
water container
paper towel
scissors
tape

Instructions

1. You will need 16 craft sticks to make the picture frame. Glue four craft sticks together edge to edge. Repeat three times until you have four sets of four craft sticks.

2. Place the sticks in a square shape, one set of four at the top, one at the bottom and one on each side. Glue the ends together at each corner.

3. Turn the frame over. Glue craft sticks flat, edge to edge, to create a solid back. Let the glue dry.

Sue's Tip

Craft sticks are really wonderful for crafting with large groups of kids. They are available in large quantities and are very inexpensive. One box goes a long way. They are great on vacation and at the cottage.

4. Paint the front and back of the frame with one to two coats of red acrylic paint. Allow drying time after each coat.

5. Cut interesting shapes from the Fun Foam, keeping them fairly small. Glue the shapes all over the front of the frame.

6. Glue different colored buttons around the front of the frame, giving it dimension and color.

7. Cut a piece of ribbon 12 to 14 inches (30 to 35 cm). Glue one end of the ribbon to one side of the frame and the other end of the ribbon to the other side of the frame. This creates the hanger.

8. To put a photo in the frame, trim your picture to fit the opening of the front of the frame. Use a little piece of tape to hold the picture in place.

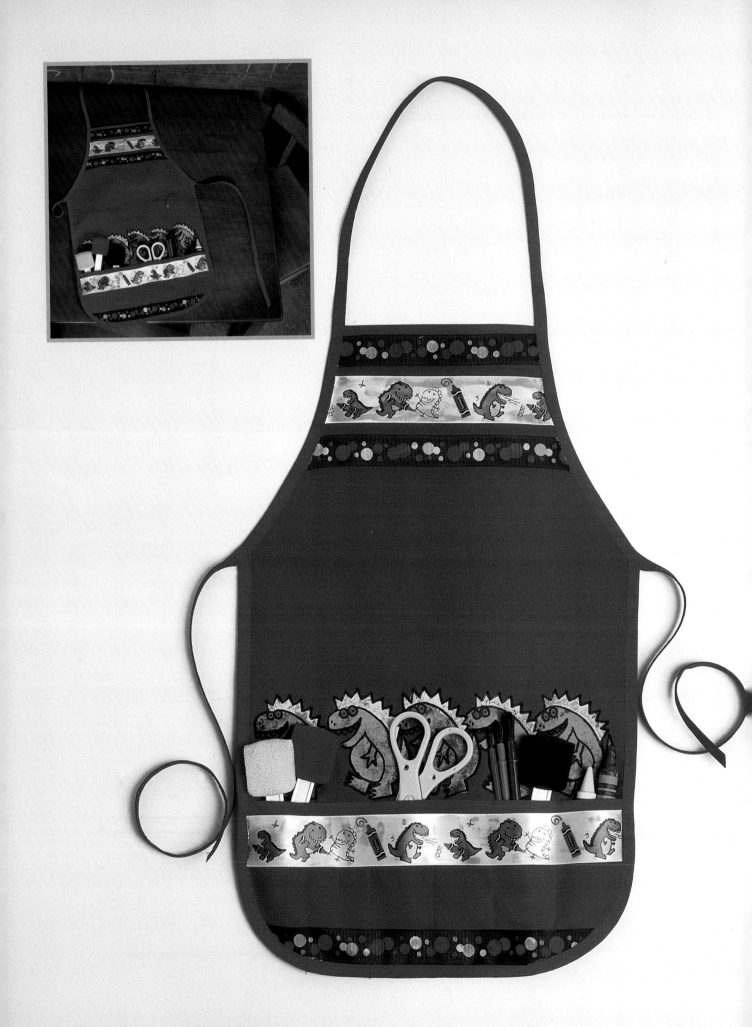

Kid's Creative Apron

Materials

1 child's apron with a bib and pockets, any color
2 yards (1.8 m) 1½ inch (4 cm) Offray dinosaur ribbon
2 yards (1.8 m) 1½ inch (4 cm) Offray polka dot ribbon
1 package Crayola large washable crayons
1 pair Crayola safety scissors
1 small foam paint brush

Tools

sewing machine
scissors
fabric glue

Instructions

1. Sew lines of stitching down the pockets of the apron with the sewing machine to create smaller pockets for the crayons. The small pockets should be approximately 2 inches (5 cm) wide.

2. Cut two strips of dinosaur ribbon and one strip of polka dot ribbon the width of the apron's bib.

Sue's Tip

Looking for a fast and relatively inexpensive way to keep the floor and carpets in your home clean when the kids are exercising their creativity? Visit your local hardware store and purchase a painter's canvas drop sheet. It is heavy enough to protect just about anything and can be easily folded up and put away.

3. With fabric glue, glue one piece of the dinosaur ribbon across the top of the bib. Leave a ½-inch (1.25 cm) space and glue the piece of polka dot ribbon in the same manner. Leave another ½-inch (1.25 cm) space and glue the second piece of dinosaur ribbon across the apron.

4. Glue a piece of polka dot ribbon across the front top of the pocket and a piece of dinosaur ribbon across the bottom of the apron.

5. Fill the pockets with the crayons, scissors, brushes and anything else you may want and your little artist is all set.

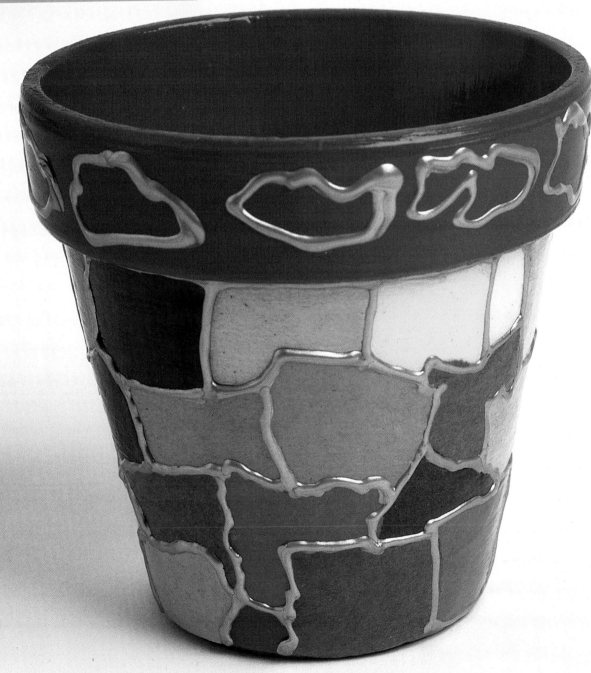

Perfect Pencils

Materials

1 package colored construction paper
1 4-inch (10 cm) clay pot
1 small bottle gloss Mod Podge
Folkart acrylic paint:
 1 bottle Engine Red
Plaid Fashion fabric paint:
 1 bottle Gold Metallic

Tools

small foam paint brushes
water container
paper towel

Instructions

1. Using different colors, tear the construction paper into small pieces, approximately 1 inch (2.5 cm) across.

2. Paint the entire clay pot with two or three coats of the red acrylic paint. Allow drying time after each coat.

Sue's Tip

A great way to get the most out of felt-tip markers is to keep them upside down. Try this idea. Decorate the outside of a small shallow dish or tin with construction paper. Pour wet plaster into the tin. Sink the caps from six markers into the plaster approximately ³/₄ of the way up, making sure they stay straight. Allow the plaster to dry around the caps. This does not take long. Insert the markers back into the caps. The markers stay upside down and organized.

3. With a clean small foam brush, apply podge to a small area of the side of the pot. Place a piece of construction paper onto the wet podge and flatten the paper down. Apply a coat of podge over the piece of construction paper. Repeat this process, varying the colors of paper until the entire pot (except the rim) is covered. You will have created a stained-glass look. Let the podge dry.

4. Apply a second coat of podge over the entire pot, including the inside. Allow it to dry.

5. Using the gold fabric paint, outline each piece of paper, and make little squiggles or hearts on the rim of the pot. Allow the pot to dry overnight.

Funky Mouse Pads

Materials

2 inexpensive mouse pads
Americana acrylic paints:
 1 bottle True Blue
 1 bottle Boysenberry Pink
 1 bottle Lemon Yellow
 1 bottle Ebony Black
gift wrapping paper or comic strips (optional)
1 small bottle gloss Mod Podge
1 can Illinois Bronze Crystal Clear glaze

Tools

scissors
small foam paint brush
water container
paper towel
sea sponge
masking tape
ruler

Instructions

1. Apply four to five coats of black acrylic paint to the surface of the first mouse pad. Allow drying time after each coat.

2. With the masking tape, make stripes ½ to ¾ inch (1.25 to 2 cm) apart on the pad. Paint in between the tape with various bright colors of acrylic paint. Let the paint dry. Add more coats if needed.

3. Once the paint is completely dry, remove the tape and allow some extra drying time.

4. Have an adult spray the top of the mouse pad with clear glaze and allow it to dry. Repeat the coats of glaze until you are satisfied with the result.

Sue's Tip

If your home is anything like mine, the kids seem to be invited to a birthday party every other week and it gets harder and harder to come up with different ideas for gifts. Why not try something a little different, like these mouse pads? The kids can get involved and feel great about giving a gift that is different from all the rest.

Instructions for Character Mouse Pad (not shown in photos)

1. Cut a starburst pattern around the outside of the second mouse pad.

2. Apply four or five coats of bright acrylic paint to the top of the pad. The pad will absorb a lot of the paint. Allow drying time after each coat.

3. Sponge the top of the mouse pad with a bright contrasting color of paint and allow it to dry.

4. Cut out your favorite characters from old wrapping paper or comic strips.

5. With a clean small foam brush, apply a coat of the podge to the back of the characters and glue them to the top of the mouse pad.

6. Apply another coat of podge to the entire surface of the mouse pad and allow it to dry.

7. Have an adult spray the top of the mouse pad with clear glaze and allow it to dry thoroughly. Repeat this process until you have the shiny surface you desire.

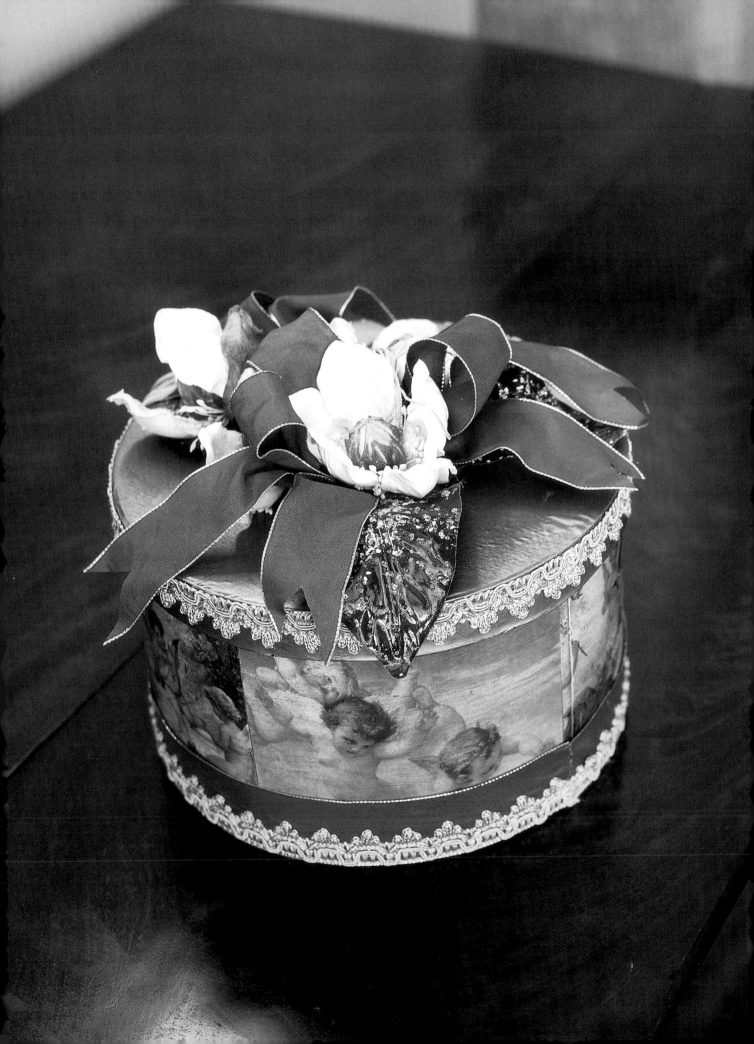

Decoupage
Decadence

Keepsake Box

Materials

1 medium wooden box with lid
1 can Deft Stepsaver Honey Oak Stain
1 package Backstreet Hand Painted floral
 alphabet decoupage paper
 (No. 16028)
1 broad-tip gold paint pen
Americana acrylic paint:
 1 bottle Raw Sienna
1 can Americana matte acrylic sealer/
 finisher spray

Tools

fine grit sandpaper
paper towel
medium foam paint brush
water container
scissors
ruler
pencil
Aleene's Designer Tacky Glue
soft cloth
narrow masking tape
small flat paint brush

Instructions

1. Sand the box and lid until smooth. Remove all dust particles with a damp paper towel.

2. Shake the can of stain well. With the medium foam paint brush, apply a coat of the stain to the entire box, inside and out, as well as the lid. Allow the stain to dry thoroughly.

3. Cut out the floral alphabet pieces. Choose letters that suit the size of your box.

4. Place the letters on the lid of the box. Using a ruler and pencil, make sure the letters are evenly spaced.

Sue's Tip

The proper tools are essential for good crafting results. Designate an area in your workshop for general supplies. Keep your tools in a safe and convenient spot, and you'll never have to go hunting when you need something.

5. Apply a thin layer of glue to the back of the first letter. Place the letter on the lid of the box, using your markings to guide you. Use the soft cloth to press the letter flat. Continue this process with the remaining letters. Keep the letters flat while they are drying.

6. Apply two pieces of masking tape approximately 1 inch (2.5 cm) apart to create a stripe around the middle of the outside of the box.

7. Using the small flat paint brush, paint in between the tape with two or three coats of the acrylic paint. Allow drying time after each coat. Remove the tape.

8. With the gold paint pen, outline the letters on the box lid and the stripe around the outside of the box. Let them dry.

9. Apply three or four coats of the sealer/finisher to the entire box and lid, inside and out. Allow drying time after each coat.

Cozy Coat Rack

Materials

1 Walnut Hollow wooden plaque 10" x
 20" x 1" (25 cm x 50 cm x 2.5 cm)
1 bottle Plaid Royal Coat antique decoupage
 finish
Americana acrylic paint:
 1 bottle Santa Red
brightly colored wrapping or decoupage paper
4 coat hooks with screws

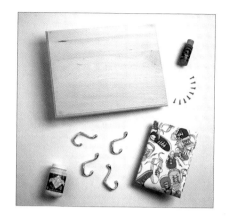

Tools

paper towel
small foam paint brush
water container
pencil
scissors
ruler
drill and small bit
screwdriver
fine grit sandpaper

Instructions

1. Sand the plaque well. Wipe off the dust with a damp paper towel.

2. Apply one coat of the decoupage finish to the plaque to seal the wood. Allow it to dry.

3. Paint the sides and back of the plaque with two or three coats of the red paint. Allow drying time after each coat.

4. Turn the plaque face down onto the wrong side of the wrapping or decoupage paper. Trace the plaque with a pencil onto the paper. Cut out the traced pattern.

5. Apply a layer of the decoupage finish onto the front of the plaque. Place the cut paper, right side up, onto the front of the plaque. Smooth the paper flat from the middle out until all the air bubbles are gone. Allow this to dry.

6. Apply two coats of the decoupage finish to the entire surface of the plaque, including the sides and back, allowing the finish to dry after each coat.

7. Center the four hooks in the middle of the plaque equal distances apart. Mark the positions of the screw holes with your pencil.

8. Using the drill, make small holes where your marks are. Position the hooks and screw them into place with the screwdriver.

Sue's Tip

Decoupage has been popular for a very long time. As with most art forms, the methods followed and the products used have changed considerably. For example, I like to incorporate photographs into my decoupage for a personal touch. You do not have to use the actual photo; instead, use either a color or black and white photocopy. Black and white photos look wonderful enlarged on a laser photocopier.

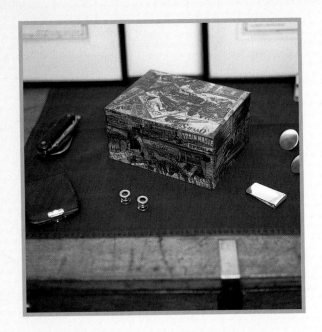

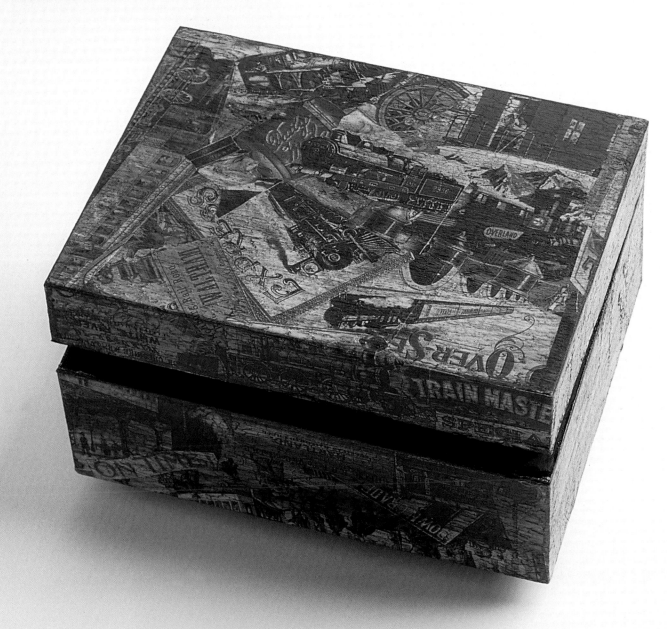

Just for Him

Materials

ı Walnut Hollow medium-sized creative box
Folkart acrylic paint:
 1 bottle Black
1 package Plaid decoupage paper suitable
 for a man
1 bottle Plaid Royal Coat decoupage finish
1 bottle Folkart crackle medium
1 small bottle Folkart satin acrylic varnish
Plaid Antiquing Wash:
 1 bottle Walnut Brown

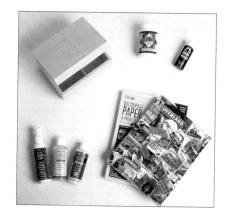

Tools

fine grit sandpaper
paper towel
small foam paint brush
water container
small sharp scissors
soft cloth
small sea sponges

Instructions

1. Sand the box, smoothing all edges and rough spots. Wipe the dust from the box with a damp paper towel.

2. Paint the entire box, inside and out, with two or three coats of the black paint. Allow drying time after each coat.

3. Cut the decoupage motifs from the paper.

4. Apply a layer of the decoupage finish onto a small area of the box. Begin laying the motifs, overlapping them as you go and applying decoupage finish to hold the pieces in place. Continue this process until you have completely covered the box, including the bottom. Trim any uneven edges with the sharp scissors.

5. Apply a coat of the decoupage finish to the entire surface of the box and allow it to dry overnight.

6. Follow the manufacturer's instructions carefully to apply a thick coat of the crackle over the entire box. Allow the crackle to dry completely.

7. Apply a coat of the varnish with even sweeping strokes. The crackle will crack the varnish. Allow the box to dry completely.

8. Spray a fine layer of the antiquing wash over small areas of the box at a time. Gently wipe the excess wash off with a slightly damp soft cloth. The antiquing wash will remain in the cracks and crevices created by the cracked varnish. Let the wash dry completely,

9. Apply a final coat of the varnish. Let it dry.

Sue's Tip

Paper is relatively thin and does not require much decoupage finish. Tissue paper requires even less again. If you oversaturate the paper, you may tear it. For best results, allow one hour between coats. To achieve an even, smooth look, gently sand between coats and always protect your work with varnish.

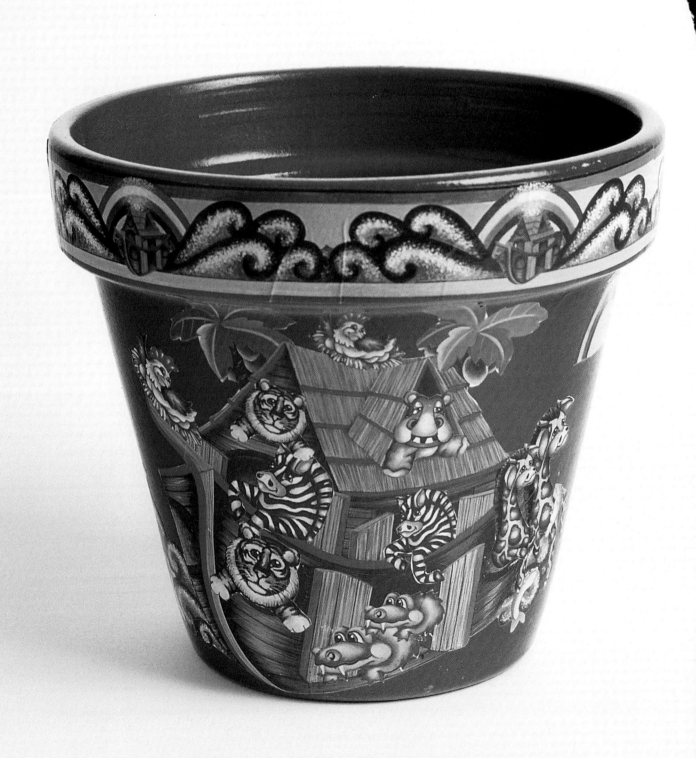

Noah's Ark Kid's Accessories

Materials

1 polyurethane ceiling molding
1 large clay pot
Design Master spray paint:
 1 can White
 2 cans Blueberry
1 package Backstreet Hand Painted Noah's
 Ark decoupage paper (No. 16039)
1 bottle Plaid Royal Coat decoupage finish
1 can Americana gloss acrylic sealer/finisher
 spray

Tools

small sharp scissors
small foam paint brush
water container
paper towel

Instructions

1. In a well-ventilated area, spray the ceiling molding and the large clay pot with two or three coats of the white spray paint to seal. Allow drying time after each coat. Repeat with Blueberry spray paint

2. With the small sharp scissors, cut several motifs of the animals and the ark from the decoupage paper.

3. With the small foam brush, apply a coat of decoupage finish to the back of each cut piece. Press the pieces on the flat part of the ceiling molding and around the outside areas of the clay pot, smoothing each piece out. Space the pieces appropriately. Allow this to dry overnight.

4. Spray both pieces with two or three coats of the sealer/finisher in thin, even coats. Allow drying time after each coat.

Sue's Tip

Carry the Noah's Ark theme onto the walls, headboard and valance of your child's room. You can use the decoupage paper for many other purposes. Choose colors from the paper and incorporate them into the bedding and window treatment.

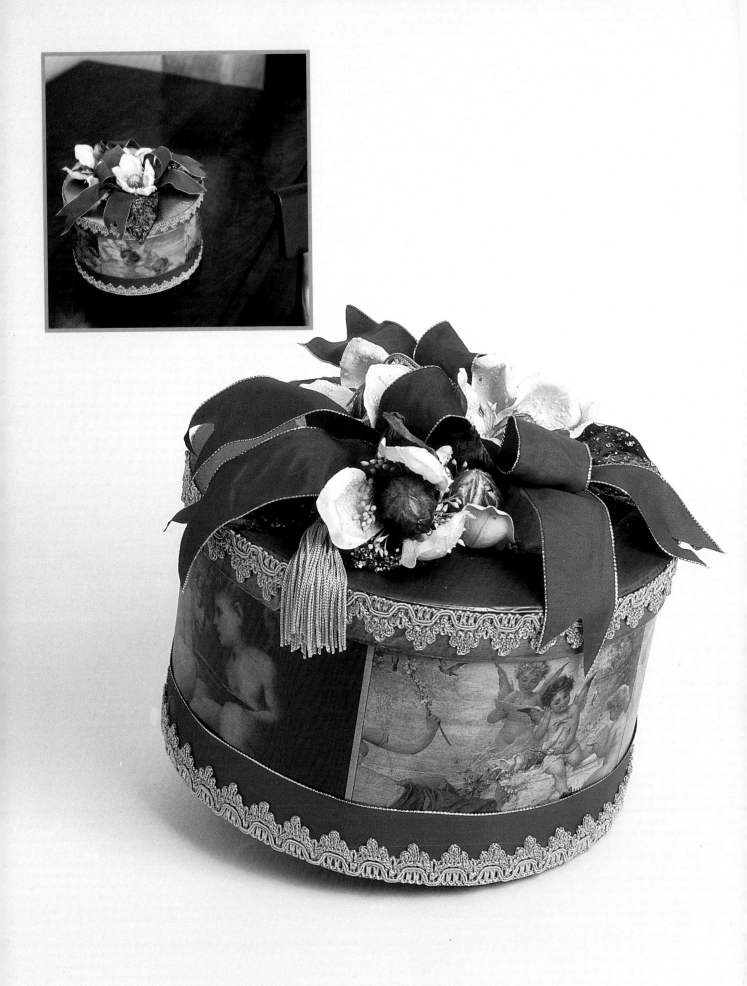

Angelic Gift Box

Materials

1 11-inch (27 cm) round papier mâché box
Americana metallic paint:
> 1 bottle Glorious Gold

6 "Angel and Cherub" greeting cards
1 bottle DecoArt oak gel stain
1 can Americana matte acrylic sealer/
> finisher spray

1 spray silk flowers with leaves
3 yards (2.75 m) 1½-inch (4 cm) Offray
> wired ribbon

2 Domcord Belding gold tassels
2 yards (1.8 m) Domcord Belding decorative gold trim

Tools

medium foam paint brushes
water container
paper towel
scissors
glue gun with glue sticks OR
> Aleene's Designer Tacky Glue

soft cloth

Instructions

1. Paint the papier mâché box inside and out with two or three coats of gold acrylic paint. Allow drying time after each coat.

2. Trim the cards to fit around the sides of the box and meet up evenly.

3. Apply a small amount of glue to one side of the box and apply one of the greeting cards. Flatten the card down smoothly. Repeat this process with the other five cards, butting each one against the next as you go. Trim edges where necessary.

4. With a medium foam brush, apply a coat of the gel stain to the entire box, including the lid. Allow the gel to sit a few seconds, then rub it off. If you wish a darker appearance, apply more gel. Allow the box to dry completely.

5. Spray the box with two or three coats of the sealer/finisher. Allow drying time after each coat.

6. Glue flowers, leaves, loops of ribbon and tassels to the lid of the box in a pleasing manner.

7. Glue a band of ribbon around the lower edge of the box. Glue the decorative gold trim on top of the ribbon. Glue decorative trim around the edge of the lid.

Sue's Tip

This box makes a great gift or can be used at Christmas to hold greeting cards. Angels and cherubs are very popular but you can use the same technique with different types of cards to make all kinds of gift boxes. For instance, use suitable wedding cards to make an envelope box for a wedding.

Suppliers

The products used in this book are available at better craft stores across North America. However, if you have difficulty finding any of the products, you can reach these suppliers at the numbers listed below:

Binney & Smith Canada
Manufacturers of Crayola and Liquitex
50 McIntosh Drive, Suite 225
Markham, Ontario Canada
L3R 9T3
Telephone: 1-800-Crayola (272-9652)
(Canada and U.S.A.)

Mumby & Associates Ltd.
Distributor of Buckingham Stencils
7040 Financial Drive
Mississauga, Ontario Canada
L5N 7H5
Telephone: 1-800-668-1124
(Canada and U.S.A.)

Plaid Enterprises, Inc.
P.O. Box 2835
Norcross, Georgia U.S.A.
30091
Telephone: 1-800-842-4197
(Canada and U.S.A.)
Web site: http://www.plaidonline.com

Sheldricks Inc.
(wholesale only)
9206 Dickenson Road West
Mount Hope, Ontario Canada
L0R 1W0
Telephone: 1-800-263-6479
(Canada only)
Web site: http://www.sheldricks.com

Walnut Hollow
1409 State Road 23
Dodgeville, Wisconsin U.S.A.
53533-2112
Telephone: 1-800-950-5101
(Canada and U.S.A.)

Winward Silks of Canada, Inc.
6225 Danville Road
Mississauga, Ontario Canada
L5T 2H7
Telephone: (905) 670-0888
Toll-free Fax: 1-888-946-9273
(Canada only)
E-mail: wsilks@winwardsilks.com
Web site: http://www.winwardsilks.com

DecoArt
P.O. Box 386
Stanford, Kentucky U.S.A.
40484
Telephone: (606) 365-3193
Web site: http://www.decoart.com

Domcord Belding
660 Denison Street
Markham, Ontario Canada
L3R 1C1
Fax: (905) 475-7022
(fax only)

Fiskars Canada Inc.
201 Whitehall Drive, Unit 1
Markham, Ontario Canada
L3R 9Y3
Attention: Cathy Whitehead
Telephone: (905) 940-8460
Fax: (905) 940-8469
Web site: http://www.fiskars.com

Offray Ribbon Canada Inc.
433 Chabanel Street West, Suite 205
Montreal, Quebec Canada
H2N 2J3
Telephone: (514) 858-7073
Fax: (514) 858-7076

Michaels, The Arts and Crafts Store
8000 Bent Branch Drive
Irving, Texas U.S.A.
75063
Telephone: (972) 409-1300
Web site: http://www.michaels.com